DRAW MANGA

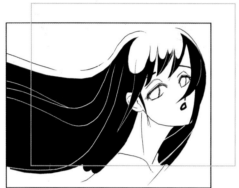

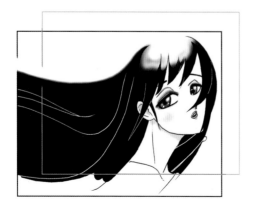

DRAW MANGA

BRUCE LEWIS

COLLINS & BROWN

To Our Lady of Guadalupe
and to Saint Luke, Evangelist and patron of artists

AD MAJORAM GLORIA DEI

First published in Great Britain in 2005 by
Collins & Brown
151 Freston Road
London
W10 6TH

An imprint of Anova Books Company Ltd

10 9 8 7 6 5 4 3 2

British Library Cataloguing-in-Publication Data:
A CIP catalogue record for this book is available from the British Library.

ISBN 1 84340 188 6

Designer: Anthony Cohen
Project editor: Miranda Sessions
Copy editor: Alison Moss

Reproduction by Anorax Imaging Ltd
Printed and bound by CT Printing, China

This book can be ordered direct from the publisher.
Contact the marketing department, but try your bookshop first.

www.anovabooks.com

Contents

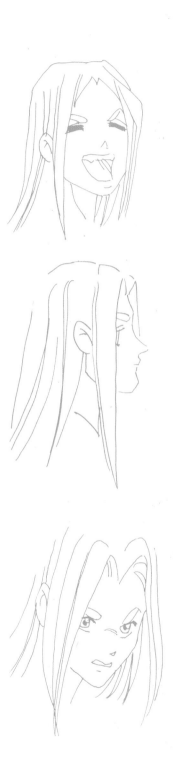

Introduction

Prepare to start crafting comics with the substance of manga, which echo those elements that make Japanese comics such a unique and interesting medium.

First, gather up all the manga and manga-related books that you own and stuff them into a plastic bag. (Make sure you get your favourites as well as any 'how to draw manga' books.) Then put this bag at the back of a cupboard and forget about it, at least until you have read all the way through this book.

You are now ready to Draw Manga.

What this book does

Or, more precisely, you are now ready to use your own creativity to produce an original work of comics art based upon the manga idiom. This book is designed to help you do that.

Here is the reason I ask you to put out of sight whatever manga and how-to books you might own. Those books could easily get you started off in the wrong way, the lame way, the some-other-guy way. The manga themselves will only tempt you to copy your favourite artists' styles and visual vocabularies; the how-to books will give you step-by-step instructions on how to make comics with just enough 'gussied-up' stereotypical 'manga' style to seem authentic to those who know nothing about the Real Thing. Oh, those books will teach you how to draw 'manga' all right – a pastiche of supposed manga-style comics, that is.

This book is different. I am not interested in showing you how to create fake manga. I have no desire to see people wasting their time learning how to draw bad imitations of some other person's art, including my own.

In fact, if your goal is to learn how to draw 'manga' that look just like the ones done by [insert your favourite manga creator here], please close this book now and seek help elsewhere.

This book may be entitled Draw Manga but, oddly enough, its real purpose is not to teach you how to 'draw manga' – for that is by nature impossible! – but to help you use the various styles, formats and techniques of modern Japanese comics to create comics stories in your own style.

How to get the most from this book

I won't lie to you. It's going to be tough. Nothing worthwhile is easy. But if you are one of the rare few with the desire and discipline to drag a project

Below are the characters who will guide you through the story.

B-Chan
An author and manga artist, B-Chan runs a small manga studio out of his home. Over the course of his artistic career B-Chan plumbed the wisdom of the East to create the Seven Steps of Manga, an advanced artistic discipline which he teaches to one worthy student per year. Creative but lazy, "Sensei" is overly fond of whisky, naps and food.

Hana Flores
A recent art school graduate, common-sense Hana is the part-time assistant at Studio B-Chan. When not serving as B-Chan's gal Friday and motivational inspiration (i.e. keeping the boss in line), she is president of the Saturday Afternoon Manga Circle, and is also drawing and writing her first complete manga. An over achiever in many aspects of her life, Hana has nevertheless found little time for romance.

into existence, then this book is going to be a goldmine for you.

In it, we'll learn about how manga got its start and where it's at today as a medium; we'll discover precisely what manga is (and is not); we'll see what makes manga different from Western comics; we'll investigate how to use Japanese comics' techniques and make them your own; we'll plumb the secrets of how to come up with powerful and memorable story ideas, characters and settings. We'll look at the pluses and minuses of the manga idiom and how you can put these lessons to use to create comics of depth, interest and vitality without slavishly copying the works of those who have gone before.

But before one can draw manga, one must first know how to draw. With that in mind, we'll learn drawing techniques to provide you with the tools you need to draw people, places and things; tips to make your characters and your story come alive; and how to physically get all of this creativity on to paper. Finally, we'll look at the production process, so that you will be able to make and publish your very own manga, either as an individual or as a group – the manga circle – and market it through conventions, seminars and websites.

And we'll have a fun time doing it, of course.

Whether you have a fully equipped home office with the lastest computer equipment and software or just a quiet corner with a few pens and pencils, paper and card, this book will give you the encouragement and advice to get going on your own manga. Both the manual and digital approach to production and printing are discussed, so you will be able to achieve your goal no matter what!

The manga medium is not a single, starlike point of light, with one style or story to be endlessly reflected by others. It is a galaxy composed of billions of different, brightly shining storytelling opportunities and artistic styles. If you are one of the millions of readers who have been dazzled by that galaxy, if you have dreams of becoming one of its stars – then read on. Let's launch ourselves into the exciting universe of manga, and discover how we can make it our own.

Patchy Neko
Puffy and female calico cat and companion of B-Chan. Possesses a powerful Sleep Ray. Fond of petting, naps and food.

Christopher 'Imo' Yadav
Imo is a college art student majoring in Cartooning (to the dismay of his parents, who wanted him to go to dental school). He's also good at sports, but not much of a ladies man. He harbors many common illusions about manga.

CHAPTER 1

What is Manga?

Those other 'draw manga' books just sort of assume you *know* what manga is. The ones that do define it for you almost always get it wrong. In this chapter we discover what manga *really* is – how it started, what makes a manga, and most importantly, what manga is not.

Draw Manga

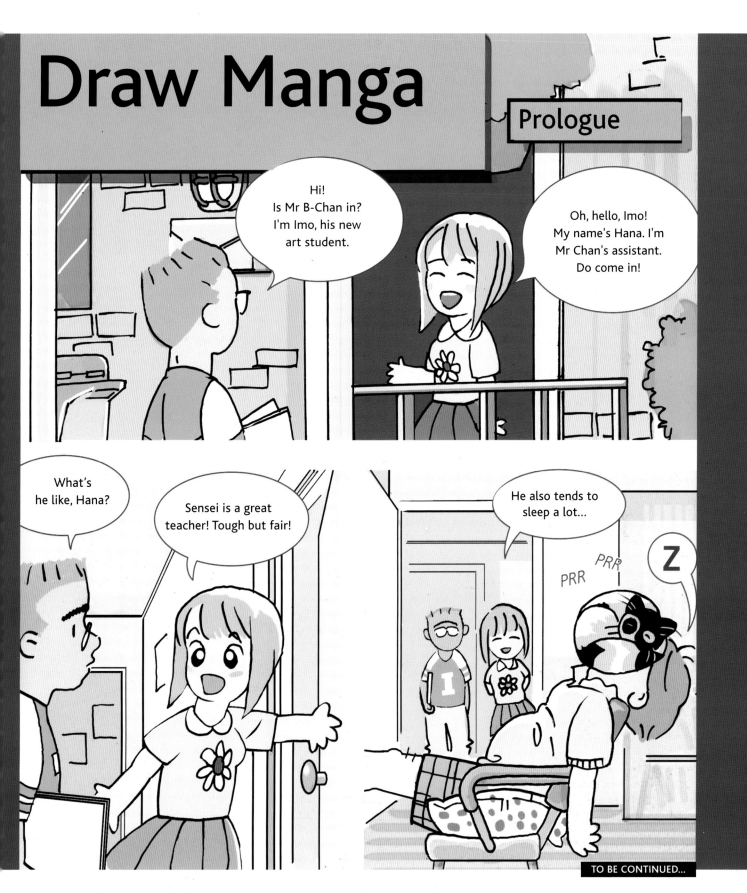

Origin of Manga

Manga: just what is it? Big eyes? Robots? A genre of comics? Let's look at some definitions and go from there.

Origin and definition

The term manga was coined in 1814 by the great Japanese artist and printmaker Hokusai Katsushika (1760–1849) – usually known as Hokusai – who is most famous in the West for his evocative woodblock prints, such as *The Great Wave*.

Like most modern manga artists, Hokusai started out as an understudy in the studio of another artist, but soon exceeded his master; his collections of picturesque illustrations and scenes of everyday life in old Edo were popular, and in time were collected into booklets and sold. These were the first manga collections.

The word manga (pronounced 'MAHN•gah') is written with the kanji 'man' and 'ga'. The characters used contain the essence of the medium:

'man' (involuntary) + 'ga' (pictures). According to manga expert Frederik L Schodt, 'Hokusai was evidently trying to describe something like "whimsical sketches"' when he coined the term. As such, the expression manga denotes a drawing made lightly, whimsically or in jest – in other words, a doodle or cartoon.

At base, that's what manga are: simply put, they are cartoons – Japanese cartoons.

But what is a cartoon, exactly?

What is a cartoon?

Cartooning is among the most ancient of arts. Anyone familiar with the cave paintings created by our Cro-Magnon forebears knows that cartoonists have been around forever. When Ugluk the Ice-Age Illustrator sat down at the old cave wall to draw some pictures, he chose subjects familiar to him: animals, hunting scenes, the guy in the cave next door with a spear sticking in him. Ugluk did the best he could, and indeed created a

Manga

great many beautiful works of art.

When we look at Ugluk's oeuvre today, however, it's obvious that he wasn't going for realism in his art. Ugluk was not out to depict reality as it was; instead, his goal was to create simple marks that symbolized those things. By reducing the visual image of whatever he was depicting to the bare minimum of lines and coloured areas necessary for easy recognition, Ugluk was engaging in the intellectual act of abstraction. Consider the following definitions.

Abstraction: the process of separating the mental essence of a thing from the physical thing itself. Abstraction is an intellectual feat unique to humankind, and is the basis of all forms of drawing.

Drawing: a form of visual representation in which two-dimensional images of persons, places, things or ideas are created with the intention of recreating the essences of those things in the mind of the viewer. All types of drawing are by nature

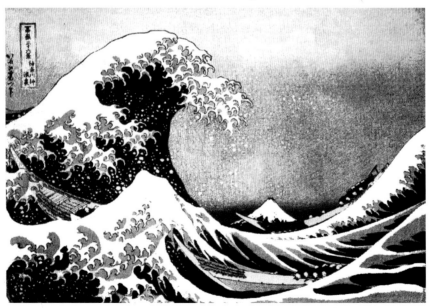

The Great Wave by Hohusai Katsushika.

processes of abstraction. Cartoons differ from other types of abstract drawings because they are abstract in the extreme; the more abstract a drawn image is, the more 'cartoony' it is said to be.

Cartoon: A highly abstracted drawing of a person, place, thing or idea intended to recreate the essence of that thing in the mind of the viewer.

Cartooning versus comics

The art of cartooning may be further divided into two types: static cartooning and sequential cartooning.

Static cartooning: cartoons representing a single event taking place at a given instant in time. Typified by a single illustration, static cartoons are most often used as vehicles for humour (e.g. gag cartooning of the type found in magazines such as *The New Yorker*) or the expression of opinion (editorial cartooning).

Sequential cartooning: Cartoons representing a sequence of events taking place at several instants in time. These instants are depicted by the use of a sequence of panels (or frames, in the case of animated cartoons). By observing this sequence of panels, the viewer experiences the events depicted as occurring over time; in other words, sequential cartooning creates the illusion of the passage of time in the mind of the reader. The class of sequential cartoons includes humorous strip cartoons, narrative cartoons of various types and animated cartoons.

This illusion of events occurring in time created by a sequential cartoon is called the narrative, i.e. the telling of a story, and it is this narrative that makes a comic strip or comic book different from all other types of cartooning. The narrative is the essence of comics.

With all this in mind, we arrive at our own home-made definition of comics:

Comics: Sequential cartoons that tell a story.

But manga in the sense we are discussing is more than just cartooning. Manga is sequential, narrative art – storytelling – with a uniquely Japanese twist.

The idiom

Simply put, manga are comics in the Japanese idiom.

But what is that idiom, exactly? To find out, we're going to need to look at the history of manga first. Manga wasn't always built around storytelling, after all; it started out as static cartooning.

And that brings us to Bishop Toba, the first-known creator of Japanese cartooning.

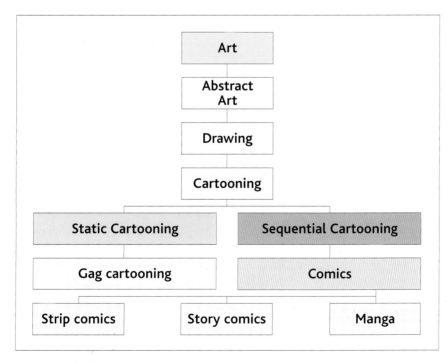

The manga family tree.

A Brief History of Manga

Now let's look at the roots of manga and find out how and when it started by tracing the earliest Japanese cartoons and their characteristics.

Cartooning is an art form ancient to Japan. As far back as the sixth and seventh centuries AD, Japanese artists were drawing caricatures of faces, funny animals and erotic art on all sorts of surfaces, including walls and ceilings. (This is one reason why I think 'doodle' is a good translation of the word manga.)

Much of this early Japanese art was stylistically similar to that of China, whose culture greatly affected the tastes and techniques of early Japanese artists. While other foreign influences were present in Japan at this time, through interaction with traders such as the Dutch (as depicted in the novel *Shogun*), none had the lasting impact of Chinese culture.

Then, in 1633, the door was slammed shut on all that. In an effort to consolidate his power, the Tokugawa shogun Lemitsu forbade the Japanese from travelling abroad and decreed a policy of near-absolute isolation from the outside world. Foreign technologies, such as gunpowder and firearms, were banned; adherents of foreign religions, such as Christianity, were tortured to death in vast numbers; and all foreign books were prohibited (and if found, destroyed).

Japan began two centuries of isolation from the rest of humankind; the nascent art of Japanese cartooning, like the rest of Japanese culture, would thenceforth develop in a very pure form free from outside influence or inspiration.

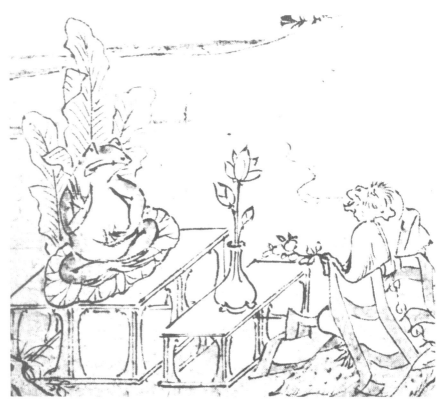

A section of the *Animal Scrolls* by Bishop Toba, a.k.a. Kakuyuh.

Toba

The first known Japanese cartoonist was a man of the cloth. Bishop Toba, a.k.a. Kakuyuh (1053–1140) was a monk with a great sense of humour, a love of animals and a deft drawing hand – a kind of medieval Buddhist Walt Disney. At the time, all of Japan was head-over-heels in love with Chinese art, music, history and culture, and the good Bishop was no exception. Steeped in those Chinese artistic influences present in Japan since the 500s, he created the first funny-animal cartoon in history, a series of Chinese-style illustrated scrolls called the *Chohjuhgiga* (*Animal Scrolls*), in which anthropomorphic foxes, bunnies, monkeys and other creatures are depicted as monks, priests, nobles and religious figures. (Toba portrayed the Buddha himself as a frog.)

The sight of fuzzy creatures all dolled up in priestly and/or noble vestments and engaging in satirical send-ups of religious and court rituals was hugely popular in 11th-century Japan, and the scrolls were in great demand among Bishop Toba's admirers.

Although he didn't use panel borders as we know them, Bishop Toba made use of the continuous scroll format and artistic dividers such as cherry blossoms and maple leaves to create a non-narrative sequence of cartoon art that would ring down the ages of Japanese history. The impact of this and Bishop Toba's many other works (he also did cartoons about mad monks, genital weightlifting and even poo!) would be echoed by succeeding generations of Japanese scroll artists, who used cartoon scrolls to depict subjects as disparate as ghosts, hell, diseases and even flatulence. (As any reader of manga knows, these are still popular subject matter for manga creators of our own day.)

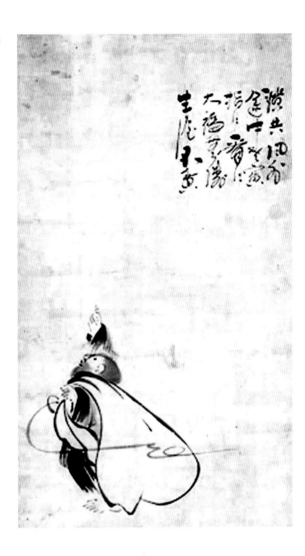

Example of zenga by Fugai Ekun (1568–1654) entitled *Hotei* (c. 1600).

Zenga

Further down the manga timeline (c. 1650) came zenga (Zen pictures), a kind of cartooning intended as an aid to Buddhist meditation.

Like Toba's works, however, these cartoon scrolls and similar religious cartoons were intended primarily for society elite; in the days prior to the invention of the printing press, each scroll was a hand-painted, hand-crafted work of art, far too rare and precious for the average rice-farmer or fisherman to own. It wasn't until the advent of woodblock printing in the Edo period (1600–1867) that cartooning became an art form for the masses.

The floating world of ukiyo-e

The 17th century brought Lemitsu's decree of isolation; Japan was now cut off from outside artistic influences, but innovation didn't stop. With the rise of a bourgeoisie (urban middle class) during the Genroku era (1688–1703) came a corresponding rise in demand for cheap disposable entertainment. As always, whenever a demand exists, a supply will appear. Enter our old friend Hokusai, creator of the term manga, and the most renowned print artist of his day. His work stands as the greatest example of the Japanese illustrative genre known as ukiyo-e.

Ukiyo-e means 'pictures of the floating world', the buoyant world of sensual day-to-day life, and artists like Hokusai delivered just that, with a series of popular woodblock prints of caricatures, blood-soaked combat scenes, exotic locales and, of course, naughty bits. These series were often sold in sets of 20 or more images, sometimes bound or accordion-folded to form books, and among the best-selling of these first cartoon books was a set entitled *Hokusai Manga*, or *Sketches by Hokusai*, issued between 1814 and 1878. In this wildly famous 15-volume set (it is said that *Manga* was reproduced so many times that the wooden printing blocks wore out!), the innovative Hokusai edges ever nearer the dividing line between static

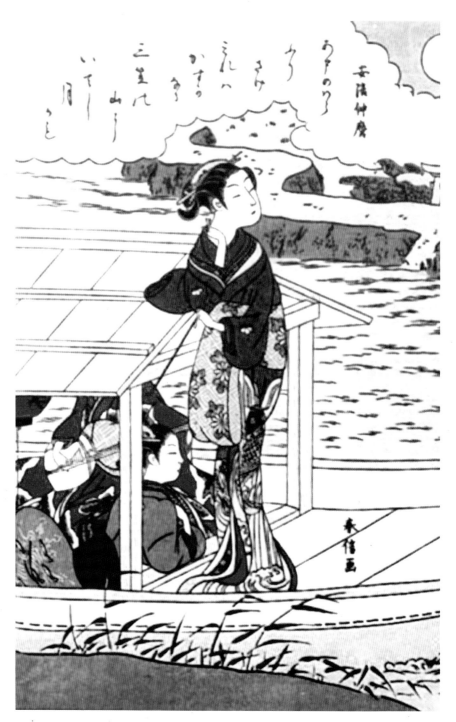

Ukiyo-e by Suzuki Haronobu (1725–1770): *Viewing the moon from a boat at Mimeguri.*

and sequential cartooning with his development of a kind of two-panel sequence called the split-frame technique. While not a narrative technique per se, the split-frame technique used by Hokusai enabled him to show the passage of time in a limited, before-and-after sort of way.

Another famous Edo era cartoon book, Shumboku Oh-oka's *Toba-e Sankokushi* (1702), spoofed daily life in urban Japan, and kicked off a craze for similar cartoon booklets, generically called Toba-e after Bishop Toba.

By the end of the 18th century, the cartoon format had evolved again; with the publication of kibiyoshi, or Yellow-Cover Books, which adapted children's fables and town stories using a picture-and-caption format, cartoon books in Japan had reached a plateau.

Hokusai Manga, Toba-e, kibiyoshi and other masterpieces of Edo era Japanese cartoon art were not merely popular in Japan; they were to prove a tremendous influence upon the artists of Europe and America in the late 19th and early 20th centuries as well. Even so, ukiyo-e and its descendants lacked the sequential storytelling element that separates narrative cartooning from static cartooning. For all their famous beauty and immense impact, they were still just pictures. A new artistic influence was needed to push Japanese cartooning over the line into the realm of comics.

That influence came steaming over

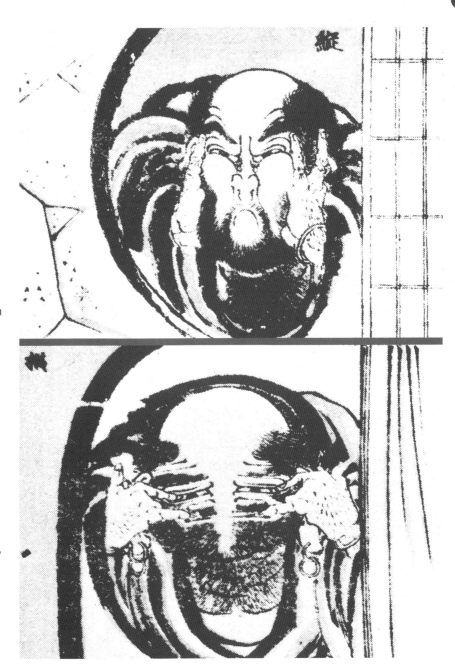

Hokusai, *Vertical and Horizontal Face* (c.1848).

the eastern horizon and into Edo Bay on 8 July 1853. With the arrival of United States Navy Commodore Matthew C Perry and his expeditionary fleet, Japan's splendid two-century isolation came to an end. Just as foreign influences in technology, politics and military arts revolutionized Japan in their respective areas, foreign art began to affect Japanese art techniques as well.

With the end of the shogunate and the restoration of the Meiji emperor, the stage was set for major change.

The First Manga

So what was this foreign influence? Sequential cartooning from America! In the early 20th century, cartoonists and newspaper publishers together created a new kind of cartoon art: the comic strip.

The comic strip

The comic strip is a distinctly American artform that was to prove immensely influential to Japanese comics creators. For example, newspaper strips such as George McManus's *Bringing Up Father* were widely read and imitated by Japanese creators.

Comic strips took off in Japan in a big way: the number of newspaper comic strips proliferated throughout the 1920s and 1930s. As in America, the most popular of these came to be collected in book form; first as huge softcover magazines (the earliest of which, Kodansha's *Shohnen Club*, premiered in 1914). Unlike American publishers, however, Japanese publishers also collected their most popular strips into quality hardcover editions. These were the first comic books in the modern sense of the word, and they were widely available in Japan thanks to a system of privately owned, for-profit, lending libraries called kashibon'ya.

It was at about this time that the term gekiga (drama pictures) came to be used as a term for comics, especially those intended for an adult audience. Many of the most famous manga artists of the post-war period got their start drawing gekiga for the pay-library market.

Among the best known of the early Japanese comic strips were 1930's *Spihdo Taroh* (*Speedy*) by Sakoh Shishido, *Bohken Dankichi* (*Dankichi the Adventurer*) by Keizoh Shimada (published in book form in 1935) and,

most notably, 1931's *Norakuro* (*Black Stray*) by Suihoh Tagawa.

Tagawa's Norakuro character, a black stray dog abstracted in a Disneyesque funny-animal style, became the subject of one of Japan's first character merchandising fads – a sort of Jazz Age Hello Kitty – and is still popular today.

But Norakuro was more than just a funny animal and a merchandising phenomenon; he was a soldier – a Japanese soldier. Tagawa's strip detailed the comic pup's rise through the ranks of the Imperial Army from private to captain. As ethnic fascism began to take hold of Japanese society in the late 1920s and 1930s, militaristic themes began to creep into children's cartoons at an increasing rate, and Japan began its slow slide into war.

And war has no place for funny animals, however militaristic they might be. In 1941, with the Second World War looming on the horizon, Norakuro was cancelled; other Japanese comics would soon follow. Those that remained would soon become perverted from their original intent of bringing laughter to everyday

Nontoh, from *Nonki na Tohsan* (*Easy-Going Daddy*) by Yukata Asoh (c. 1924).

people into tools of the ruling clique in Tokyo, propaganda for use in the establishment of the Greater East Asia Co-Prosperity Sphere – the Japanese Empire.

Manga goes to war

The Second World War (ironically called the Pacific War in Japan) was a disaster for that country, and for Japanese cartoonists. Those artists who were not drafted and sent into combat or on to the assembly lines were recruited for use in the creation of various propaganda or psychological warfare materials; others were put to

Jiggs, from *Bringing Up Father* by George McManus (1923).

work as homefront morale boosters. Japan's burgeoning comic book industry was ravaged, first by the government's increasingly harsh censorship, then by wartime propaganda demands, and finally by American incendiary bombs. By the end of the war, the few comic books left in Japan were crudely made propaganda screeds hardly worthy of the name.

Then came the Bomb, and the end of the war. As American forces streamed into the country to begin the occupation, Japan lay in ruins, her people hungry and poor, her cities wastelands of rotting ash. Death and destruction were everywhere.

But from out of the ashes of war came a phoenix of creativity. Japanese society was about to be reborn – and with it, the cartoon, which would one day spread to influence the entire world. Fittingly, it was a doctor of medicine who would preside over the birth of this most astonishing child.

The god of comics

Osama Tezuka (1928–89) bestrides the world of comics – all comics, not just Japanese comics – like a colossus. Without his enormous talent and influence, the history of world cartooning would be vastly different, and nothing like manga would exist in its present form.

Some have called Tezuka 'the Walt Disney of Japan' for his contributions to cartooning in general; to my mind, he is really more of the 'Winsor McCay of Japan'. As well as being a multimedia genius and a brilliant businessman, Disney was primarily known and loved for his unforgettable funny-animal humour cartooning throughout his career as a cartoonist. Winsor McCay, the first genius of American cartooning, was a master of narrative, and, while humorous, his stories (of which Little Nemo is the most famous) centre upon human fears, fantasies and foibles. Osama Tezuka had a sense of humour, oh yes – a keen one, with a puckishness that Disney productions often lacked – and a heaven-sent gift for storytelling, to

Yesterday and today by Norakuro.

be sure; but unlike Disney and McCay, his comics were created primarily with drama in mind, and when he did draw cartoons of animals, such as Jungle Emperor, they were generally far from being 'funny' in the Mickey Mouse/Gertie the Dinosaur tradition. Unfortunately he had little of the Disney/McCay gift for business; in fact, his enterprises were plagued by insolvency and bad management throughout his long career.

But oh, could he create!

At the time, the only comics widely available in Japan were a few

newspaper strips and the so-called aka-hon, or 'red books', a kind of cheap comic book with reddish covers, copies of which were crudely printed on pulp paper and sold at candy stores and the like. Published in Osaka, these inexpensive comic books provided affordable entertainment for the children (and adults) of post-war Japan – and a golden opportunity for Tezuka, then a teenage medical student at Osaka University. His first strip, done for a national children's newspaper, was well received, but the publication of Tezuka's first aka-hon manga – 1947's *Shin Takarajima* (*New Treasure Island*) – was nothing less than revolutionary.

Nothing like this comic had ever been seen before, and other Japanese creators were amazed. *Shin Takarajima* had a long, exciting story, a well-developed cast of characters and dazzling cinematic layouts and pacing. In their 1975 autobiographical comic *Manga Michi* (*The Way of Comics*), the artistic combo known as Fujio-Fujiko (creators of the legendary Doraemon manga) talk of their reaction to Tezuka's manga calling it 'a revolution in post-war comics!' Manga auteur (and Tezuka protége) Shintaro Ishinomori said of the book: 'It was shockingly new ... My encounter with *Shin Takarajima* was probably what made me decide to become a manga artist.' Others were similarly impressed.

Shin Takarajima went on to sell more than 400,000 copies (a miraculous figure in those days of widespread

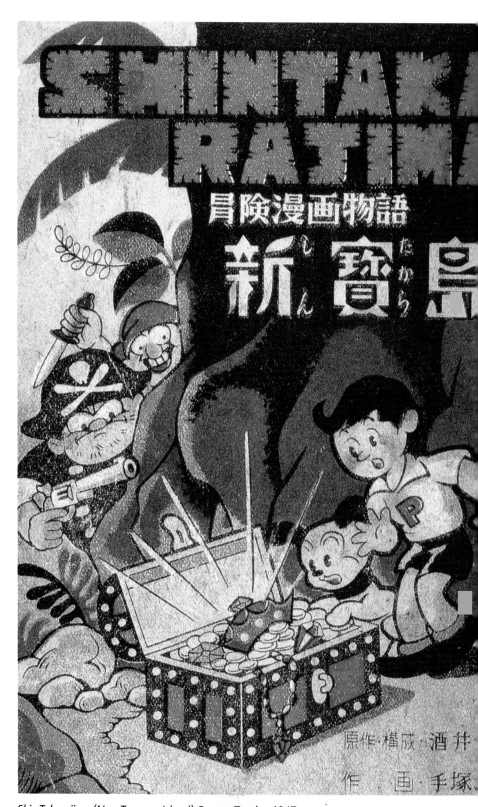

Shin Takarajima (New Treasure Island) Osamu Tezuka, 1947

poverty) and jump-started the age of manga as we know them today.

It is impossible to do justice to the career of Osama Tezuka in a historical sketch like this, so I won't try. Suffice it to say that Tezuka created or perfected most of the styles and techniques common to modern manga. Among these, Tezuka

● created the modern shohjo manga, or girls' romance comic genre (*Ribon no Kishi/Princess Knight*, 1954);
● established the visual vocabulary for the post-war Japanese manga industry, including such stylistic innovations as speed lines, travelling shots and big eyes;
● perfected the modern science fiction, detective fiction and true-life history manga;
● pioneered the modern multi-volume, super-long manga story idiom and much more besides.

Of course, Tezuka was also the creator of arguably the most well-known and beloved of all manga characters: Tetsuwan Atomu (Mighty Atom), known in America as Astro Boy.

Atom/Astro Boy the character is perhaps Tezuka's most representative creation: an atomic-powered robot in the form of a young boy who engages in a Pinocchio-like quest to discover what it means to be human. Astro Boy, Japan's most famous science fiction narrative cartoon, was not only the first instance of what would become Japan's huge friendly-robot comics genre, it was the force behind another Japanese pop culture medium: the animated cartoon, known in Japanese as anime. The *Atom/Astro Boy* anime (1963) was Japan's first domestically produced animated television series and one which pioneered the limited-animation techniques that made TV animation financially possible. (Thanks to legendary American TV producer Fred Ladd's excellent English-language version, *Astro Boy* is almost as beloved in America as in Japan.) Over the decades, Atom/Astro Boy has become a symbol of Japanese pop culture in general and manga in particular, and his popularity continues to this day on both sides of the Pacific.

In the end, Osama Tezuka was neither a Japanese Disney nor a cheap knockoff of any other cartoonist. He was unique, an artist of such rare talent and such peerless stature in his field that only one nickname truly suits him: the one by which he was known in Japan. To them, he was and is 'the god of comics'.

Modern manga

The meteoric impact of Tezuka's manga created a tsunami of creativity in the manga field – a tsunami that has broken upon the shores of both America and Europe, and one that has yet to subside. In the decades since Tezuka's manga revolution, manga have become the number one form of entertainment in Japan, where a myriad manga on every conceivable style and subject is available. Manga magazines (some of which number among the best-selling publications of any type in the world) cater to audiences of all ages and interests, now as then providing the reading public with cheap disposable fun, and manga-based anime films (some of which number among the highest-grossing theatrical releases in Japanese history) dazzle and delight both children and adults on both the small and big screens. Manga has become a permanent and indispensable part of life in Japan.

The rest of the world is slowly catching on to this exciting storytelling medium as well. This is nowhere more true than in America. Beginning in the 1990s and continuing until today, the share of the North American comics market occupied by translated Japanese manga has increased rapidly; in fact, as of 2004, manga titles 'dominate bookstore sales in the graphic novel category', a market long ignored by the publishers of traditional American-style superhero comics.

Tetsuwan Atomu (Mighty Atom) a.k.a. Astro Boy.

Attracting the girls

Another factor in the American manga success equation is the medium's appeal to female readers. Many, if not most, of the Japanese comics adapted and sold through bookstores in America are aimed at girls and women, a demographic that American publishers have more or less ignored since the 1950s. With the rise of direct market distribution (i.e. comics sold directly to speciality comics shops instead of on the newsstand) in the late 1970s, the publishers of American comics concentrated their efforts on selling to dedicated comics fans, a highly specialized, practically all-male 'boutique' audience. By marketing comics in a manner almost identical to the way hardcore pornography is sold, American comics publishers helped create a similiar public image of the comic book store. Fairly or unfairly, they developed a reputation for being seedy, disreputable dungeons frequented by maladjusted male social outcasts – in other words, a venue where respectable people (and especially women) just didn't go. To this day, with sales of American comics at historic lows, most American comics publishers still create and market their wares to appeal to the adult male comic-shop customer.

Manga publishers, on the other hand, quickly shifted business models to concentrate on newsstand distribution – the retail bookseller's trade. Beginning in the late 1990s, an increasing number of manga began to show up on ordinary retail booksellers' shelves, first as a novelty, then as an adjunct to the standard line of American comics. The results were spectacular: the brightly lit, family-friendly world of big-box booksellers was an ideal forum to introduce American readers (especially girls and women) to the world of manga. Today, translated manga in inexpensive paperback editions dominates the shelf space in most American bookstores, with traditional American comics limited to expensive hardbound or trade paperback deluxe editions (generally compilations of old comics, classic newspaper strips or funny cartoons à la Gary Larson's *The Far Side*) or to lowly spinner racks in the magazine section. Thanks to canny strategy, American manga publishers have succeeded in capturing the lion's share of the lucrative female readership, and the profits that the female demographic brings. (It is an open secret in the US that traditional American comics publishers generally derive most of their profit from sources other than selling comic books.)

The trend towards manga domination of American comics shows no sign of ending. Although an industry shakeout is sure to happen, a collapse of the manga market in the US is highly unlikely; too many readers are hooked! It is a practical certainty that from now on mangaphiles in the US, Canada, the UK and other Anglophone markets will always have access to new and exciting Japanese manga.

The future of manga

And not just Japanese manga. All around the world, the tidal wave of creativity created by Osama Tezuka continues to spread, carrying the manga ideal with it. In its wake, artists in America and many other countries are creating 'manga' of their own, not by slavishly copying their Japanese favourites, but by taking to heart the essence of manga – the manga style of storytelling – and combining it with the aesthetic of their own cultures and with their own creativity to make something all their own. This process of combination and creation is what *Draw Manga* is all about.

So What is Manga?

Before we get started on our own manga, I'd like to correct a few misunderstandings people may have about manga. By telling you what manga isn't, I hope to make it clear what exactly manga is.

Manga is not a style

'Learn to draw in the manga style'; 'Create your own manga-style characters step-by-step'; 'American comics artists turning to manga style for ideas'. We've all seen headlines like these. It seems that every bookstore has a shelf dedicated to books trumpeting the intricacies of 'the manga style'. Well, let's get one thing clear right up front, in big red letters: when it comes to comics art, there is no such thing as the manga style.

There are as many styles of manga as there are manga artists. Saying that you're going to draw a comic 'in the manga style' is like saying you're going to film a movie 'in the French style'. There might be certain things common to many French films (Edith Piaf, May/December romances, etc.), but anyone who has ever seen a French movie knows there is a world of difference between the camera work of, say, Luc Besson and that of Jean-Pierre Jeunet.

Manga does not mean drawing characters with big eyes

Yes, big eyes are a stylistic hallmark of many Japanese cartoonists, but there are plenty of manga out there with characters that have normal, proportionally correct eyes – Katsuhiro Ohtomo (Akira, Domu) to name but one. It's no more correct to say that all manga characters have big eyes than it is to say that all American comics characters have three fingers.

When it comes to drawing your own manga, don't draw big eyes on your characters because 'that's how manga characters look'; draw them with an eye-size that best suits your personal style. The sight of big eyes on a character that isn't drawn in a way that suits the big-eye style can be scary!

Manga are not 'adult comics'

Just because many manga have adult themes, situations and depictions doesn't mean every manga has to have such things. In fact, the vast majority of manga are created and published for the entertainment of children.

Many rookie comics artists succumb to the temptation to load their comics with obscene language, sex and violence simply because they can. Sometimes it's the urge to shock Mum and Dad that motivates these artists; others do it out of the misplaced idea that a proper manga has lots of this type of material in it.

Don't be one of those artists. I'm not saying you shouldn't express yourself artistically; I'm just saying use tact and good taste.

CHAPTER 2

Drawing Basics

Copying another artist's style is a waste of time. Ignore what the other how-to books say — you can't draw manga until you know how to draw. That means you need to know how to draw the human body realistically before you attempt to draw people in cartoon form. This chapter tells you how, and offers a treasury of shortcuts and tips to help you get it right.

Getting Started

To draw your own manga, all you need is a pencil, a sheet of paper, a story and a burning, all-consuming will to become an accomplished artist. Feh!

Other than that, you simply need to practise. Practise what? Practise seeing and drawing what you see.

In other words, you need to master the art of drawing from real life. Yes, I know that sitting in one place for hours at a time drawing trees, rocks, bottles and other people just doesn't have the zing of drawing robots, samurai, girls, spaceships and robots.

Tough. If you are serious about becoming a manga artist – or any kind of artist – you have to first master the craft of drawing.

Is it hard to learn to draw? Not particularly. Drawing from life is a skill that anyone with reasonable hand-eye coordination and discipline can master. In fact, it wasn't too long ago that educated people were expected to know how to draw as a matter of course. Back in 1825, for example, ordinary school students were sweating over copies of Louis

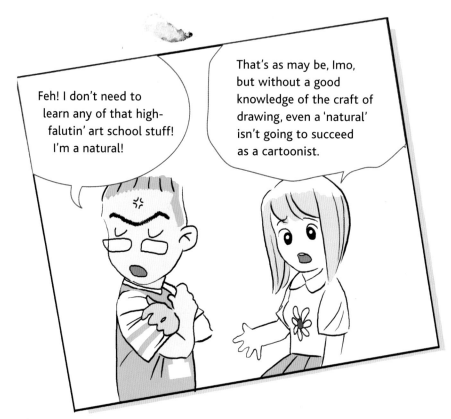

Francoeur's An Introduction to Linear Drawing, an art textbook published by William Bentley Fowle containing lessons in perspective drawing, geometry, classical art and architecture. This sort of art instruction wasn't limited to the

children of the idle rich; it was intended for ordinary kids, the sons and daughters of farmers, millworkers, fishermen and shopkeepers. If they could learn to draw, so can you.

It may be that you feel you already know how to draw well. I felt the same way when I was just starting out. Believe me, however, when I say you're fooling yourself, just as I was. (It is, of course, possible that you're a natural talent, but if so you probably aren't going to be reading this book anyway. In fact, if you can draw well without any effort, you're probably already out there making money at it!)

The truth is that no matter how good you think you are, there's always the opportunity to improve your skill.

It's easy to get excited about doing something cool...

...but it's important to know the basics before you try.

If you're looking for a convenient and inexpensive way to take a life drawing class, your local community college is a great place to start!

If you happen to have some actual ability, great, but never make the mistake of thinking you're 'good' at what you do. You're not. I'm not. No artist ever is. The best we can hope for is to be good enough.

As long as we are imperfect human beings, we'll never truly know everything there is to know on any subject, including drawing. My advice to those who have some drawing ability is to pretend that you know nothing and approach the craft as if you'd never picked up a pencil. You'll be amazed at how much you still have to learn.

So get out there and go about it! Get a sketchpad and a pencil and hone your skill as an artist to your utmost. No matter what level of talent you have, you'll find that learning to draw from life will improve your work, and bring you satisfaction on many other levels as well.

It doesn't take talent

How many times have you sat at the drawing table and, after hours of fruitless sketching, wadded up your efforts at art and thrown them away? 'Doggone it, I'm just not talented!' is something we've all said to ourselves at one time or another.

The thing is, it doesn't matter if one is talented or not. In fact, the dirtiest secret in the whole world of art is simply this:

Talent is not necessary to succeed as an artist

You read that right. History proves conclusively that talent is not strictly necessary if one wishes to succeed in art. And that goes for any form of art – music, drama, drawing, you name it. Talent is a gift. Every so often, along comes a Mozart, a Johann Sebastian Bach, an Albrecht Dürer, a Hokusai, a Charles Dana Gibson, a Charles M Schulz. Each of these artists instinctively had the ability to produce works of such superb quality that the human race had no choice but to recognize them as masterpieces. We rightly refer to such persons by the title of 'genius'.

Wolfgang Amadeus Mozart is a good example of a genius. He was an accomplished keyboardist from the moment he was tall enough to hit the keys. He composed his first minuet at the age of five, his first symphonies at nine, his first grand opera at 12 and toured Europe to rave reviews before he was old enough to shave. That's genius. That's talent. That's an example of a person who is born to play. That's a born artist.

Yet one need not be a Mozart to succeed as an artist. After all, for every Wolfgang Amadeus playing for the crowned heads of Europe, there were 500 Hans Schmidts out making an honest living playing piano in taverns, churches and cathouses. Hans didn't have Mozart's talent; Hans had to learn piano the hard way: by practising.

We can't all be Mozart, but anybody can be Hans Schmidt. Just as Hans made his living tinkling the ivories, anyone with the desire and drive to do so can learn to draw. Whatever the Average Joe or Jane might lack in talent can be made up in learned skill. And the only way to gain that skill is for one to learn one's instrument, and then practise. As an aspiring artist, your instruments are the pencil and pen, the eye, the hand and, most important, the mind. With a solid knowledge of the fundamental principles of drawing, and with plenty of practice, any of us can develop the skill needed to succeed as a cartoonist. This section will help you do just that.

I can't believe it! Mr Chan says my drawing skills need work. I guess it's true that every great genius goes unrecognized in his own time!

It's 'time' you took a few drawing lessons, Imo-kun...

Drawing from life

The foundation for any form of graphic art is life drawing – the art of seeing persons, places, things or locations in the Real World and creating an image of them on paper that captures the essence of their appearance. In other words, drawing realistic pictures of real people, places or things.

To begin your training as an artist, I suggest the following exercise: get a sketchpad (the cheapest one you can find) and a pencil (any pencil) and, for 15 minutes each day (Sundays excepted; you're allowed one day off!) sit still in one particular place and draw your own hand.

Don't worry if it looks wrong at first. You'll get better. Don't worry if you get bored; it's just your brain trying to wriggle out of doing something it's not used to. Just sit. For 15 minutes. And draw your hand.

As you draw, gently tell yourself to draw what you see. I mean literally whisper to yourself, 'draw what you see, draw what you see', and then really look at your hand. Don't try to think about it; just let the light bounce off your hand into your eye and down your brainstem to your drawing hand. You'll probably cringe at your early attempts. Don't. You're not going to do well right away. That's OK – you'll get better.

Now, I realize that when people see you staring at your hand and talking to yourself they're going to wonder what's up. To avoid embarrassing questions, I suggest you find a quiet, comfortable place to spend your 15 minutes of 'hand practice'. The kitchen table at home is an ideal location; it's well-lit, comfy, and the only people likely to see you there are members of your own family or your roommates, who are used to you talking to yourself.

Once you feel you have sufficiently mastered drawing your hand, the next step is to start drawing people. For that you'll need a model. Now, I don't mean a statuesque blonde necessarily: your brother, best friend, or the Girl Next Door will do. Again, find a convenient time and place to practise, get together there with your model two or three times a week, have them pose comfortably – in a real-life position, not stiffly; reading a book or

petting the cat are ideal – and, again, draw what you see.

I'm not convinced of the benefits of a formal art education for cartoonists, but you could always try a Figure or Life Drawing class, which is a formal class supervised by an instructor in which the students observe a live model in a classroom and draw him or her for an hour. Most local and community colleges offer them. You enrol, pay your tuition fee, buy the materials needed and show up two or three nights a week. The instructor will walk around behind the students as they draw, offering comments and suggestions.

Learning to draw from life is vital. Without a working knowledge of how to draw from life, your career as a manga artist is likely to go nowhere

fast. You can't break the rules until you know the rules, and life drawing is the

way to learn them. We'll discuss this in detail later in the chapter.

Us brains have to take in so much information just to get a drawing done!

Turn to the next page to see how we process it all...

Four steps to figure drawing

Step 1
First, lightly sketch an oval to represent the head, and then rough in the rest of the frame using the ball-and-cylinder method (see page 32).

Step 2
Then use your thumb, pencil, or a scrap of paper to measure off the seven to eight head height (see page 34); then, at the bottom, sketch in the ground line – this is where your character's feet (or boot heels) will go.

Step 3
Once you've established the character's height relative to the ground, you can remove and adjust the lengths of the various cylinders of your B&C frame until they are proportionally correct. Don't get too fussy about drawing the figure exactly seven or eight heads tall; the goal is to get your figures to look right, not for them be mathematically precise.

Step 4
Once you have the figure roughed in, place a separate sheet of paper on top of the rough and draw the finished figure using the rough as a reference.

As we go on through this chapter, you'll be asked to draw various things. For now, you will just need the following equipment:
• a regular pencil
• a package of ordinary white copy paper or typing paper
• a lightbox
We will discuss the full range of artist's materials in Chapter 3.

Mental Modelling

But why learn all of this? What does life drawing have to do with manga? Well, unless you have an idea of how things are put together, you won't be able to manipulate them realistically.

It all comes down to structure. Drawing a cartoon means deliberately distorting the structure of an image in order to create a recognizable symbol for that object, but without an intimate knowledge of the structure of people and things, your symbols for them won't be recognized. And the only way to learn structure – really learn it – is through life drawing.

'But drawing from life is hard!' Is it? Although life drawing does take skill, the physical act of making the drawing is probably the easiest part of drawing. The real work comes in learning to get over the tendency of the mind to reduce the complexities of the Real World to more easily digestible symbols.

The Real World is infinitely complex. Our brains are constantly bombarded by data – sensory data created by our eyes, ears, noses, tongues and the billions of nerve endings in our bodies as they interact with the matter and energy around us and within us.

Fortunately, we have a brain that is adept at capturing the essence of the universe around us without needing to capture all of the data it is constantly receiving from Reality. Instead of registering every wrinkle and follicle on a face, the brain just notes the basic 'face' structure and

concentrates on movements and expression to keep you updated on what's going on Out There. (The process the brain uses to do this is in many ways analogous to the data-compression codes used to transmit digital video data: as the frames load in sequence, the computer compares each frame to its predecessor, and only redraws those pixels that change from frame to frame, not the entire raster field.) The more complex Real World things are, the more our brains tend to reduce visual images to their bare bones, filling in the details internally, through imagination, based upon what we have learned from others and from our own experiences. It is thus by symbols we know reality.

Drawing by shorthand
This is why drawing from Real Life seems so hard. Our brains perceive the complicated structure of the human form and basically freak out. Our natural desire to mentally reduce complex things to simple symbols kicks in, and instead of really seeing what we're looking at, the brain registers it as a symbol. Then, when we try to draw what we see (a human eye, let's say), the brain naturally transmits the 'eye' symbol to the motor nerves that control the hand. The end result is that we tend to draw the symbol for the eye (e.g a dot, or a lemon shape with a dot in it) instead of the actual eye. This is the reason people think they can't draw well.

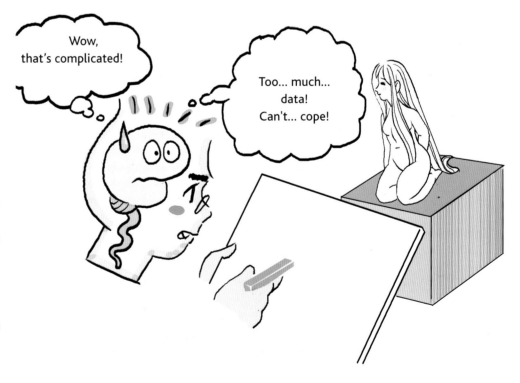

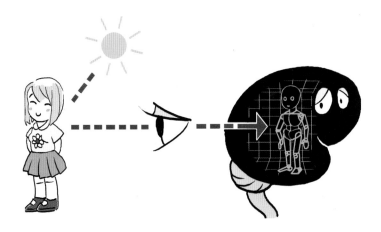

They draw the symbol of a thing without understanding the structure of the thing they're drawing.

Breaking the habit

Luckily, this sort of 'drawing by shorthand' is a habit, and a habit can be broken through an act of will. The way to break the habit of drawing the symbol instead of what you see is by training yourself to see — in other words, by drawing from life. With diligence, in time you can gradually re-programme your brain to see what you're looking at rather than just slapping a symbol on to paper to represent it. It's a kind of 'virtual reality': at any given time, when you

see something, your brain creates a 3-D model of it; each time you draw a thing from life, your brain adds data to its 3-D model of that thing, and the more data (on texture, positioning, structure, etc.) your brain has in its 3-D model, and the more detailed your internal 3-D models are, the easier it will be for you to draw a person, place or thing from scratch (i.e. without looking at an actual person, place or thing). With practice, your internal 3-D models will become so detailed and familiar to you that you will be able to tilt, rotate and distort them in any manner or to any desired position in your mind's eye — and then put that image on paper.

By training oneself to see, and to draw what one sees, the artist gains the ability to draw a person, place or thing from any imagined point of view or in any imagined position or state. This ability is crucial to becoming a cartoonist.

You can't break the rules until you know the rules. By 'taming' your brain's symbol-using capability, you'll learn the underlying structure of things, and will therefore gain the ability to draw images that look 'right', whether those images are realistic or symbolic.

From the age of six I had a mania for drawing the forms of things. By the time I was fifty I had published an infinity of designs, but all I produced before the age of seventy is not worth taking into account. At seventy-three I learned a little about the real structure of nature, of animals, plants, trees, birds and fishes and insects. In consequence, when I am eighty I shall have made still more progress. At ninety I shall penetrate the mystery of things, at a hundred I shall have reached a marvellous stage, and when I am a hundred and ten, everything I do, be it a dot or a line, will be alive.

Hokusai, *The Hokusai Sketch-books*. Translated by James A. Michener. Vermont: Tuttle, 1958

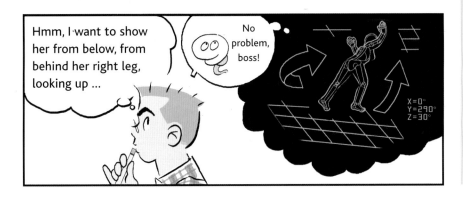

The Secret of Manga

'I don't like that manga stuff. I mean, people don't really have eyes that big in Real Life.' How often do we hear this? Yet manga is a language, and you have to learn how to speak it.

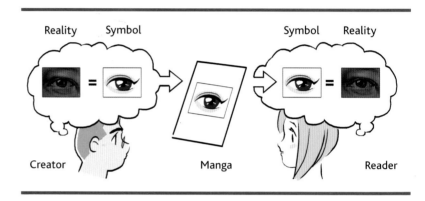

Reality Symbol Symbol Reality

Creator Manga Reader

And now, after all the effort you've put into learning not to draw symbols, I'm going to ask you to draw symbols. We have come full circle: from symbol to reality to symbol.

It works like this: the less complex a perceived thing is, the more involvement it takes us to perceive it, and the more involved we have to be to interact with it. Therefore – and this is key – the more symbolic an image is, the more real it seems to be.

This curious effect is the result of human psychology. Because our brains are good at symbol processing, we tend to be more involved with symbols than we are with other complex images.

The art of drawing manga is the art of telling a story with symbols. Instead of drawing an eye, you draw the symbol for eye, and the eye becomes real for the reader. This is why it's so important to know how to draw a real eye: without knowing how a real eye is structured, your 'eye' symbol will look childish, awkward – wrong.

Manga, a 'cool' medium
Marshall McLuhan, the great 20th-century communications theorist, divided mass media into two types: 'hot media', high-resolution media that require little viewer involvement, and 'cool' media, in which detail is low and the viewer has to fill in the details for him- or herself.

Comics, according to McLuhan, are a cool medium. The reader looks at the simple shapes of the cartoon

forms and mentally makes them come alive. To use his words: '...the old prints and woodcuts, like the modern comic book, provide very little data about any particular moment in time, or aspect in space, of an object. The viewer, or reader, is compelled to participate in completing and interpreting the few hints provided by the bounding lines.'

As a creator of manga, you have the power to create worlds that will come alive for your reader, that will 'feel' real to them.

What language do you speak?
Many people who enjoy American and European comics just do not get manga. They can't get past the big eyes, spiky hair, impossibly long legs and 'Caucasian features' that make up the cliché manga style.

The reason for this disconnection is simple, however: these people speak a different language.

Manga is not illustration. Manga is really a visual language – a kind of

hieroglyphics, or picture-writing, that developed from Japanese visual culture. Just as Western comics echo the Classical tradition of Greek and Roman visual culture, so manga reflects the iconic, ideographic nature of Eastern art and writing. Fans of Western comics tend to find it hard to 'read' the Japanese picture-language of manga because they are used to the Western picture-language of comics.

Like the Western comics artist, the manga artist has a thorough knowledge of the structure of the human body; the difference lies in the artist's use of symbols to recreate the image of the human body in the reader's mind. The gap between Western comics fans and manga is a language gap.

East versus West
Western comics are picture-writing, too, but are much less so than manga. Western comics are based in large part upon the written word. Check out a copy of *Batman* or *The Legion of*

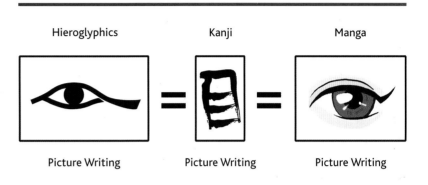

Hieroglyphics	Kanji	Manga
Picture Writing	Picture Writing	Picture Writing

Superheroes or *2000 A.D.* and see what you find: words, words, words – by the dozens per page – in the form of speech and thought balloons, captions, footnotes and so forth. In Western comics, the central principle is to tell the story, not to show it; the pictures are there merely to complement the author's text.

Manga, on the other hand, is based upon the image. A typical manga page contains far less written information than does a typical Western comic book page. It is not unusual for manga pages to have only three or four words per page, or even no words at all; the image is what matters, not the text.

And image is important. As McLuhan points out, comics media are 'cool' – they force the reader to fill in important data on their own. This mental involvement makes the subject seem much more real to the viewer than textual data can – and the essence of good storytelling is to make what is unreal seem very real to the audience.

Show, don't tell

This is the secret of manga: show, don't tell. By using the techniques of manga, you can create stories that will grip and fascinate your readers, that will draw them in to the story, that will allow them to experience your imaginary world rather than just read about it. Show, don't tell is the magic formula that gives manga its immense power as a medium.

Picture-writing

Do people have huge, saucer-sized eyes in Real Life? No. And so what? People don't have muscles like a side of beef, wear blue tights and come from the planet Krypton in Real Life, either. The next time a friend comments upon the 'unrealistic' nature of manga, please point out that American and European comics really aren't any more realistic in nature; they simply use a different picture-language to tell their story.

When a manga artist draws an eye, he or she is not drawing a picture of an eye; he or she is drawing a hieroglyphic character that stands for an eye, a symbol that communicates something about the character, not just a mere illustration of an eye. Just as a superhero's unrealistic musculature stands as a symbol of power, a manga eye stands for the inner characteristics of the character to whom it belongs.

As you proceed through the lessons in this book, always keep in mind the secret of manga: show, don't tell. It will serve you well in creating your own comics that are true to the spirit of the manga idiom.

The Figure

Learning how to make your characters move realistically is all-important. So, get to grips with the ball-and-cylinder method.

The human body is a masterpiece of the designer's art – simple in appearance, yet at the same time profoundly complex. However, the life drawing skills you've learned will come in very handy when it comes to cartooning, because now that you know the structure of the human body, you can stylize it into a collection of simple shapes that will make posing your characters a snap.

The method of stylization that I employ is called the ball-and-cylinder (B & C) method. Essentially, the body can be thought of as an assembly of jointed balls and solid cylinders, rather like the poseable wooden doll (manekin) sometimes sold at art stores. By using the ball-and-cylinder analogy, one can quickly draw the human body in any desired pose.

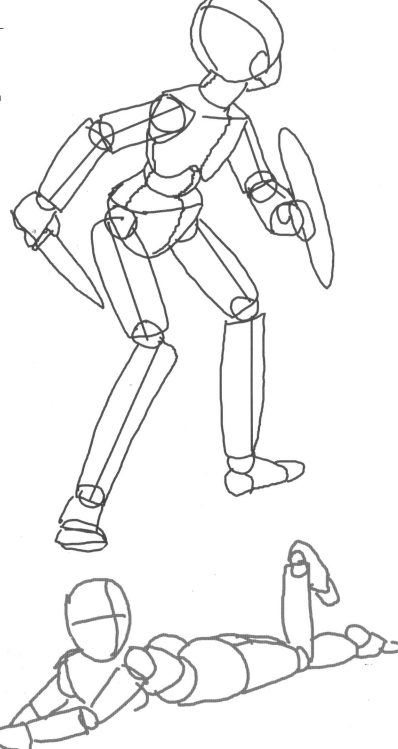

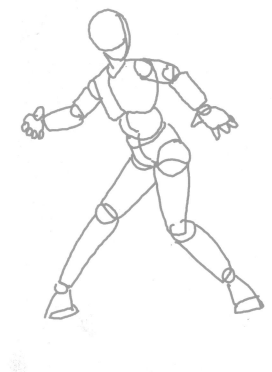

Here we see an exploded view of the basic human body structure in B & C form. Note that the complex shapes of the various body parts have been stylized, retaining their basic shape while omitting detail. The balls represent joints (in the sense of pivot points, not necessarily physical joints) and the cylinders represent the torso and extremities. An artist who has developed a detailed mental 3-D model of the body from his or her experience in life drawing can use these simplified parts to quickly sketch the figure he or she wishes to draw in whatever position is desired. He or she can then rely on his or her knowledge of anatomy to position the figure realistically and add detail.

Human form: Basic Components expolded view

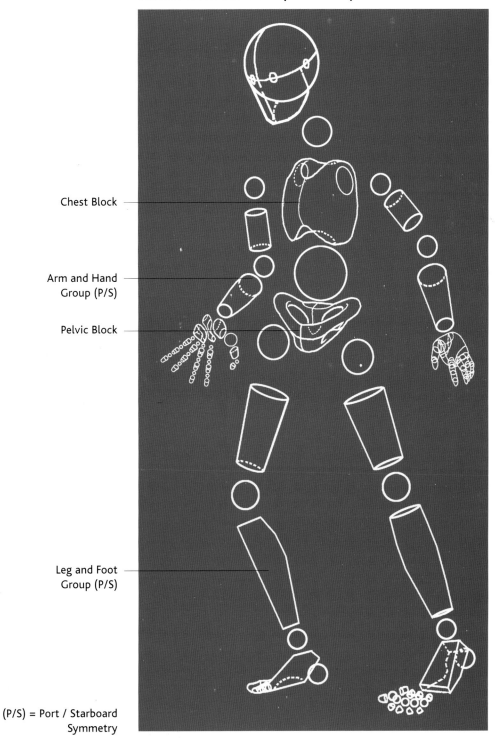

Chest Block

Arm and Hand Group (P/S)

Pelvic Block

Leg and Foot Group (P/S)

(P/S) = Port / Starboard Symmetry

Women and Men

Remember those Life Drawing classes? This is where they will come in handy, as we learn how to draw the male and female form in the correct proportion.

Ok, let's say you've mastered drawing the ball-and-cylinder figure. Your next step is to flesh out the manekin – to use the B & C figure as the frame for a fully detailed drawing of the human body. To do this, you'll need a guide to the topography of the body, a map of the human form, complete in detail and correct in proportion, and you'll need one for both female and male.

These quickie guides contain all the basics required to perfect the skill of drawing women and men in the manga idiom. Don't worry if you don't get the faces, feet, hair and other details right the first time; this is an introduction, a way to get you started, and we'll look at the particulars of face construction and so forth on later pages. What's important is that you learn to draw women and men in correct and pleasing proportion.

Manga women
Women in Real Life are about 5.5 to 6 heads tall. However, if you draw them in this realistic proportion, they will look stumpy and short to your readers. This is due to the effect of foreshortening on the printed image as seen by the human eye.

Girls drawn in manga proportion, 7 to 8 heads tall, look 'right' on the printed page, so apply this principle, as shown below (unless, of course, you want your character to look stumpy for story purposes!). Add in body details following the marked guidelines to create a well-proportioned female.

Image | Paper | View

Image | Paper | View

The effect of foreshortening upon perceived figure height.

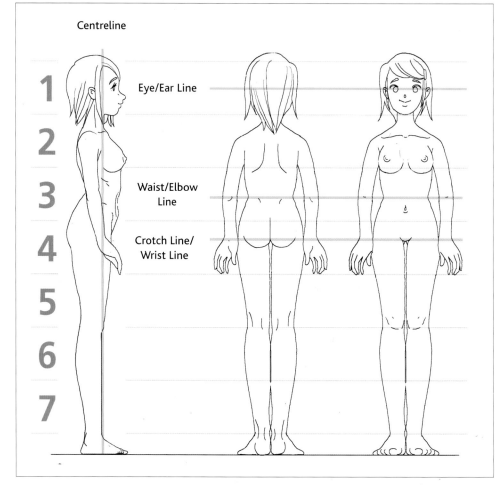

Centreline

1 2 3 4 5 6 7

Eye/Ear Line

Waist/Elbow Line

Crotch Line/ Wrist Line

Manga men

The same proportional rules go for men. Drawing them in physically correct proportions will make them look like B-chan over there on the right – all sawed-off and stout. Instead, draw men about 7.5 to 8.5 heads tall and they'll look well-proportioned.

Naturally, the 7/8 heads rule must be modified when drawing the figure in perspective, but with practice you'll soon gain a 'feel' for using it correctly. Once you have the basic figure established and in proportion, you can flesh out the figure according to the guidelines shown below.

I prefer the term 'stout' myself

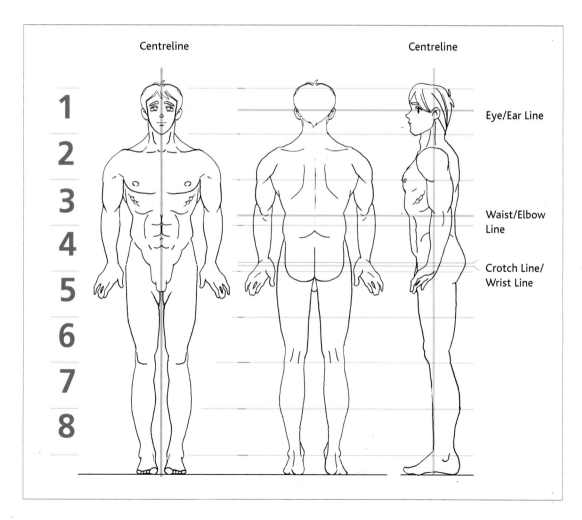

Centreline

Centreline

Eye/Ear Line

Waist/Elbow Line

Crotch Line/ Wrist Line

Aphrodite and Paris

Aphrodite

Too few artists know how to draw women as lovely and appealing as our Aphrodite here. The key is to think soft. That's not to say women are weaklings, but believe it or not the main difference between the bodies of women and men is textural – in other words, softness and smoothness. Generally speaking, women have more subcutaneous fat (fat lying under the skin) than do men, and it is this extra padding that gives ladies their delightfully soft appearance. Other factors to consider: women are, on average, shorter, more slight and more slender than men of the same age and build; their rib cages, wrists, ankles and shoulders tend to be narrower; and, of course, their pelvic structure differs considerably from that of men. Let's look at some specifics.

Face

Women's faces are generally fuller and less angular than those of men due to bone structure, muscular size and subcutaneous fat.

Neck and Shoulders

Thick necks and broad shoulders – nothing makes female characters look more mannish. In these days of female weightlifters, bodybuilders and boxers, however, many women do have pronounced muscles in these areas.

Legs and feet

Female legs tend to be more slender than the male, and slant inwards from hip to knee rather than dropping vertically. The ability to draw feet correctly and pleasingly is a skill you'll sweat over, but the results are well worth it.

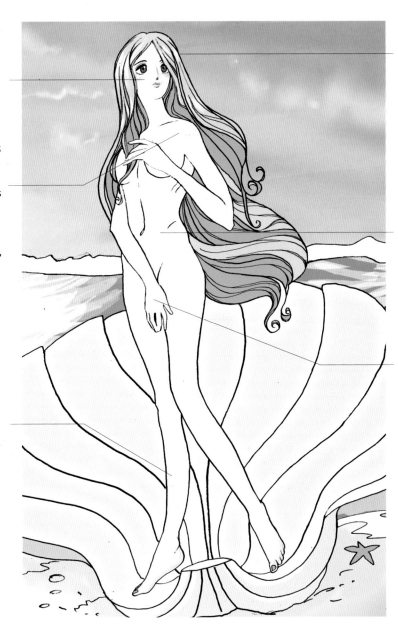

Hair

In general, women have longer hair than men. Drawing long hair that looks good can be a challenge.

Body

The delightful differences between males and females are most apparent here: not only is the female rib cage smaller and less pronounced, but a woman also has a narrower waist and pronounced breasts.

Arms and Hands

Women's arms are slightly shorter in proportion to their overall body length compared to those of men, and the muscles, bones and joints of the arms and hands are generally smaller.

Paris

As befits a shepherd who is also a prince, our lad Paris here is built like a Trojan outhouse – in other words, solidly. Most men in the Real World aren't built nearly this well, but remember we're not in the business of portraiture – stylization is our game, and nothing says Real Man like lots of good, solid muscle. Of course, you don't want to overdo it: unless you're drawing a weightlifter, a superhero or an overly developed muscleman, my advice is to stay away from the lumpy, bulky, Western style of drawing muscles. In other words, when it comes to drawing the hombres, think lean.

Our Paris is nothing if not lean: broad at the shoulder and across the chest, narrow at the hip, with defined but not bulky muscles on the upper arms and torso.

Here are some of the techniques you can use in your drawing to make sure you're drawing a man.

Face

Most men have less fat beneath their skin than women; therefore, the male face tends to have better-defined bone structure and musculature. The brow ridge and chin of males are generally more pronounced than those of females as well.

Neck and Shoulders

The male neck/collarbone/shoulder complex is surprisingly different to that of the female. The male collarbone tends to slant up from the centreline, rather than downwards, and the tendons and muscles of the neck (including the deltoids, which peek over the shoulders) are much bulkier in general. Men also tend to have much broader and more squared-off shoulders.

Arms and Hands

The average man's arms and hands are much thicker and more defined than those of the average woman. Exceptions exist for both sexes, but a careful hand will allow you to convey a slender man or a bulked-up woman without giving them a carnival-sideshow air.

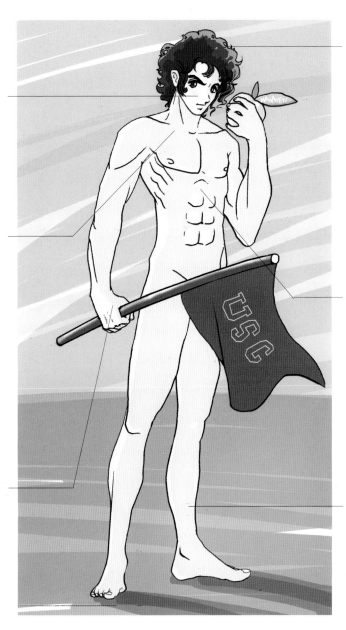

Hair

In real life, most men wear their hair shorter than women. There's no reason you have to draw it that way, however! The thing to keep in mind is that even long hair can be masculine in appearance; the key is to arrange it in a masculine way. Here, Paris sports the Shinichi Watanabe 'jafro' look that is currently all the rage among manga fans.

Upper Body

It's night and day as far as the upper body is concerned. Men's chests are in general broader than women's, more muscular and (unless the man in question is obese) lacking external breasts. The powerful muscles of the male back are visible over the collarbones as they taper up the back of the neck.

Legs and Feet

Other than the typical differences in size and muscle-joint prominence, men's feet are more or less the same as women's. Take care not to draw your he-men characters with dainty little ankles and you'll be fine.

Face the Face

The face in manga comics has distinct characteristics. In order to draw the range of faces for your manga you need to first understand what these characteristics are, and be able to apply them.

Drawing faces is probably the most enjoyable part of cartooning. However, the human head is a complex object and one that takes practice to draw well. On these pages we'll look at some techniques you can use to make drawing it easier.

You have to think in 3-D to get the head right, and one way to do that is to imagine that the human head is rather like a globe.

Building the perfect face, manga style

Using this analogy, you can think of the head as having an equator running around its middle, and a meridian running around it from top to bottom. The place where these two lines meet is where the face will be; the north and south poles are the crown and the base of the head respectively. The

features, hair and jaw structure are attached to this sphere as shown in the illustration below.

As demonstrated, the skull is basically a globe with a bony brow and the upper/lower jaws sort of stuck on the front. The reality is, of course, a bit more complicated, but if you've been practising your life drawing you already know that. The thing to remember is that the skull's shape can be simplified into four parts: the brain bucket, which is the cranium; the brow, which is the bony ridge that surrounds and protects the eyes; the jaw structure, both upper and lower; and the cheek, the cheekbone and fleshy covering that wraps around the jaws and gives the face fullness. These are the four parts that you'll use to construct your characters' faces and give them life.

Such a baby face

There is no one way to draw a manga face. There are as many kinds of faces in Japanese comics as in Western comics. Yet just as Western comics artists tend to draw characters whose faces follow the proportions of those found in classical art, manga artists tend towards drawing faces that are cute. In this lesson, we're going to take a brief look at cuteness and how to draw cute faces.

What is the key to drawing the cute face? Neoteny – the retention of childlike features into maturity. It makes sense that we should like things that look childlike; after all, human beings the world over have a built-in desire to love, protect and take care of babies and young children. That desire carries over to things that share the same proportions as those of young

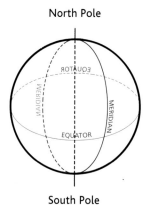

North Pole

EQUATOR

MERIDIAN

MERIDIAN

EQUATOR

South Pole

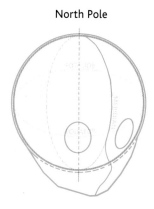

North Pole

A globe is a sphere divided into a top half and a bottom half by its equator, and into two hemispheres by an imaginary line called a meridian. It also has a north pole and a south pole, with an axis running through the centre of the globe between them.

children, too: anything with big eyes, a large head, a small mouth, fluffy hair, rounded features and a general air of softness and cuddliness is going to be regarded as cute by most people, no matter where they are from. From puppies to kittens to teddy bears and Hello Kitty, as a species we love things that remind us of babies.

So, in order to draw the cute face, we have to forget drawing our characters' heads in the correct proportions of the adult human skull (top right). Instead, we draw our characters with the general facial proportions typical of a baby's skull (top left).

In practical terms, this means drawing the brain bucket, forehead and eyes bigger, and the jaw smaller than they are for an adult skull. This stylization has the effect of shortening and widening the face when we draw it, which in turn means that the eyeline no longer falls on the exact equator of the head. Instead, we must imagine a new line circling the skull a short distance below the equator, a line which I call the eye-quator, as shown above. The eye-quator marks the line where the pupils will fall on the face.

The baby's skull (above) has a smaller brow ridge, bigger forehead, smaller jaw, larger eye sockets and larger brain bucket than the adult skull (above right).

Equator
Eye-quator

Baby Young Teenager Adult Middle-Aged Aged Be Seeing You

I told you I'd be back!

Two faces have I

In general, there are two basic facial types: the round face and the long face. Which face you choose to draw will depend upon the age, type and demeanour of your character. Remember, your goal is not to draw a picture of a face, but a symbol that represents the character in your story; therefore, your sweet, playful or childlike characters should have sweet faces that mirror those characteristics, whereas your more sober, serious, more mature characters should have faces that symbolize those attributes. (Exceptions exist, of course; it might be fun to occasionally draw a cute face on an evil character, or a mature face for a childlike character.) In all cases, however, the eyes should be drawn expressively, and should be centred on the eye-quator.

A word about big eyes. Big eyes are an artistic convention, not a requirement. It is entirely possible to draw a manga story in which the characters' eyes are more or less proportional to 'real' eyes. In general, however, the size of the eye serves an important role as a symbol of the inner world of your character. The general rule is that the bigger, 'deeper' and more expressive a character's eyes are, the more sympathetic that character is to the reader; the smaller or 'flatter' the eye is drawn, the less sympathetic or human the character is intended to be. Again, exceptions exist: experiment and use your artistic judgement to determine just how big your 'big eyes' should be.

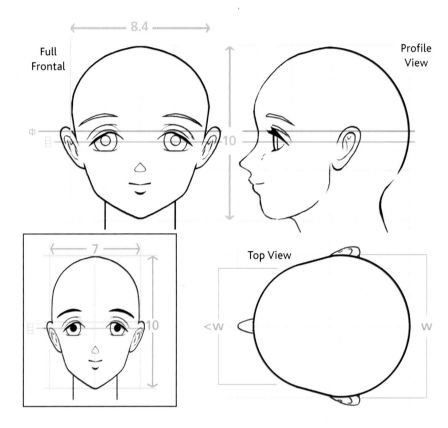

Full Frontal

Profile View

Top View

General manga proportions

The basic round-face manga head is proportioned as in the 3-D view above top (approximately 1:8.4). The face is 4 eye-widths wide (the eyes being set 1 eye-width apart). Please note that the brain bucket is wider at the back and narrows to a flat front (the forehead). Chins may be drawn as rounded, square or pointy, and cheeks as sunken, chiselled or chubby, depending on artistic needs.

The long-face head is proportioned slightly differently from the round-faced head (roughly 1:7). Basic head structure and eye proportion remain constant.

I feel like such a fool

Face Dances

The heads that you draw need to be able to move. Here's some basic information about representing the head as a 3-D object.

The apparent shape and size of the head varies according to the yaw (angle of rotation) of the head upon the neck, and the pitch (tilt) of the head upon the spine. The appearance of the head for a given yaw/pitch combination is called its visual aspect, and you'll need to learn the various visual aspects of the face for the nine basic frontal positions shown here. (There are also nine basic rear view positions, but since your characters will most frequently be seen facing the reader, I have omitted them here.) Combined with the six side view, or profile aspects (see opposite page for profile view), a total of 15 frontal aspects of the human head exist, and you'll need to master them all.

Rotation (YAW)

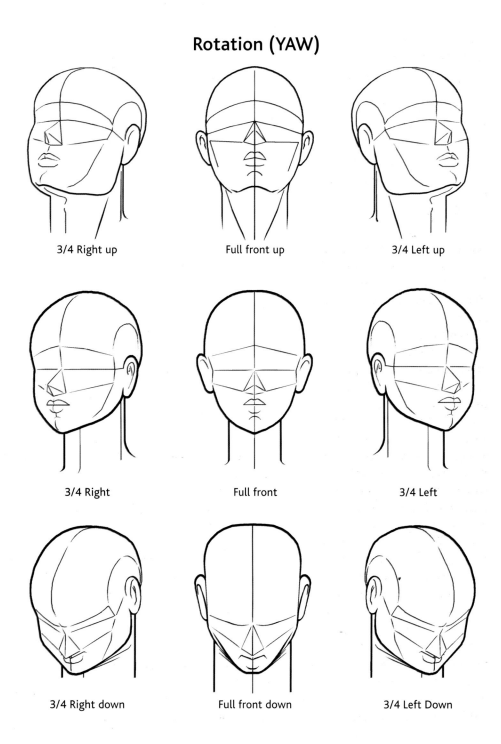

3/4 Right up · Full front up · 3/4 Left up

3/4 Right · Full front · 3/4 Left

3/4 Right down · Full front down · 3/4 Left Down

Step-by-Step: The Female Face

It's said that the cartoonist who can draw beautiful girls will never go hungry, so let's go through the process and learn the basics.

Tip
For these sketches, I used a lightbox to let me flip my sketches over and redraw them on the back side of the paper. Reverse-angle drawing, as it is called, is important when doing faces. Seeing your sketch from both directions will highlight any mistakes you have made, such as one eye drawn too high or too low, etc.

Step 1
All faces begin with the standard globe-and-jaw head shape. I start my drawing there, with simple pencilled-in ovals. I draw in the equator, the eye-quator and other construction lines, but I don't fuss too much about being exact – this is only the beginning.

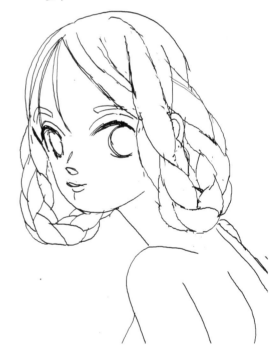

Step 2
Now it starts to get interesting. I plug my lightbox into the socket and flick the switch on. Then I flip the drawing and, with the light shining through, I sketch it again in pencil from the reverse angle. Once I have the basic head shape, I correct and/or fix the positions of the eyes, nose, lips, cheeks and brows; I position the neck; and I rough in the hairstyle. Here I am drawing a Spanish girl called Carmencita, and use a book of historic paper dolls for reference. Details such as hair and clothing styles are important!

Step 3
Clean-up time. I reverse the image once more and redraw it in pencil again, taking care this time to draw the linework the way I want it to look in the finished drawing. I also fix the neck, shoulder and back anatomy.) With no construction lines cluttering up the image, this sketch is starting to look like an actual drawing.

Step 4

Another redraw, this time in solid black line. (I used a digital tablet to redraw this particular piece in my computer, but pencil and paper works, too.) Notice I use different widths of line to add depth and visual interest to the drawing. (The width, or weight, of your lines should always vary within the same drawing: more about this later.) I also carefully draw in various wisps and locks of hair to show the viewer that it's a mass of strands, not just a solid object. Beware of creating the dreaded 'hair helmet' effect.

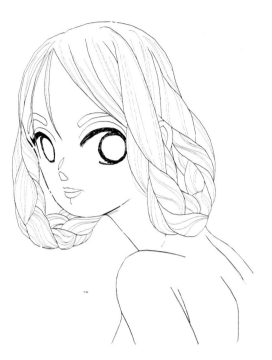

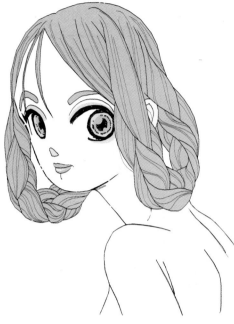

Step 5

The last two images are just for show, so don't worry about following along from here. We'll discuss these techniques in detail in Chapter 3. Once your basic drawing is done, you may choose to add tone to your drawing as shown here. Tone refers to any technique used to create a 3-D effect by showing shadows, reflections and other differences in value (the intensity of the light reflected from an object). Since Carmencita's hair is as black as an evening in Spain, I have given it a darker-valued tone to symbolize that. The tone here was applied digitally, but I could have used pencil, markers, crosshatching, screentoning, or other methods to add tone. More on these techniques to come.

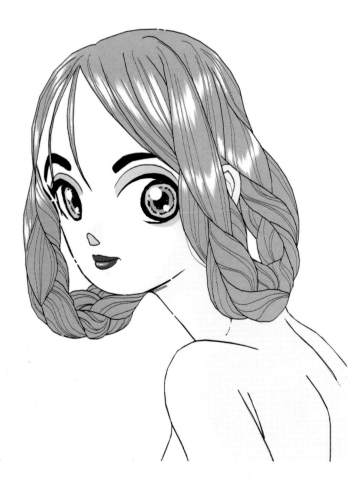

Step 6

To finish up, I've added highlights – absences of tone that symbolize the look of bright light being reflected off a smooth surface. Two main kinds of highlights are shown here: shines, the effect of light reflecting off hair, and stars, those spots of white that make cartoon eyes look bright. (Again, we'll cover these topics in detail in Chapter 3.) You can add highlights by erasing pencil marks, by using white ink, your computer's graphics software, or by simply not drawing anything where you want the highlights to go.

Step-by-Step: The Male Face

While based upon the same basic skull shape, the male face differs from the female in a variety of ways. Let's go through the construction of a male face step-by-step and look closely at these.

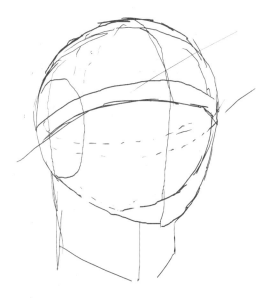

Step 1

Again, we start with the basic globe-and-jaw, equator/eyequator construction. Note that at this angle we can see the u-shaped structure where the jawbone turns just under the point of the chin. You'll want to study the underlying bone structure to get a feel for how to draw this area.

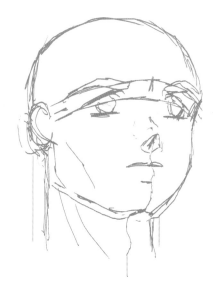

Step 2

The basic shape of the face is drawn. Notice that I've drawn the brows, chin, jaw and cheekbones as being much more pronounced than on the female face. Men in general have a heavier bone structure than women, and this is reflected in the facial features.

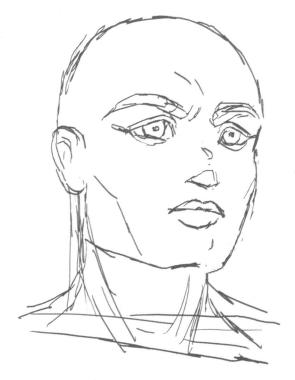

Step 3

The face takes its final form. Note that I've reduced the roundness of the cheek, emphasized the brow with a couple of crease marks and outlined the ropy tendons of the male neck.

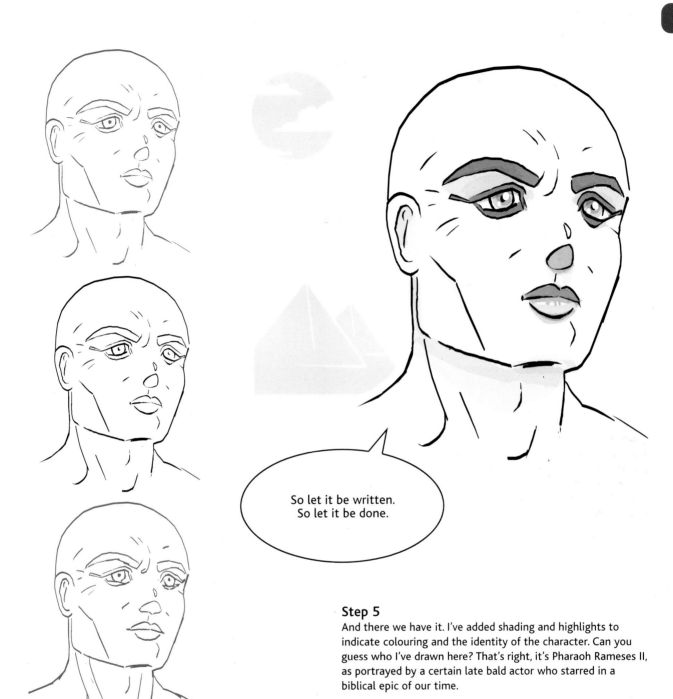

So let it be written.
So let it be done.

Step 5
And there we have it. I've added shading and highlights to indicate colouring and the identity of the character. Can you guess who I've drawn here? That's right, it's Pharaoh Rameses II, as portrayed by a certain late bald actor who starred in a biblical epic of our time.

Step 4
In these intermediate sketches, I refine and adjust the features, adding emphasis marks for the chin and the facial creases (don't overdo these!) and refining the lips and nose a bit. (You should flip your drawing at each step and draw it in reverse so as not to screw up your basic construction.)

Hands

As I mentioned before, it can be very difficult to draw hands that look right. Here are the hands of manga and how to draw them.

The Spectrum Method

The human hand is an extremely complex assemblage of bone, muscle, connective tissue, glands, follicles, chitin, fat and skin. As such, there is a lot of ground to cover to get it just right. As always, drawing from a real-life model is recommended: remember the first life art exercise I gave you earlier? I suggest starting a 'handbook' – a sketchbook in which for 15 to 30 minutes a day you draw nothing but your own hand, from every possible angle and in every possible position.

Once you have the structure down pat, you can then simplify the complex structure into a cartoon. One easy way to break the hand down to the basic parts is to use the Spectrum Method.

It works like this. The hand has seven basic parts: the index finger; the middle finger, the ring finger; the 'pinky' or little finger; the area at the base of those last three fingers; the thumb and 'ham' (the muscular 'ball' at the base of the thumb); and the palm. By assigning one of the seven colours of the white-light spectrum to each part, it's easy to make sure you've drawn them all. The seven colours of the spectrum are red, orange, yellow, green, blue, indigo (dark blue) and violet, easily memorized by using the initial letter of each colour in the acronym ROY G BIV. In this analogy,

the little finger is given the label red, the ring finger orange, the middle finger yellow, the index green, the finger base blue, the palm indigo, and

the thumb and ham violet. If you're missing a colour, you've drawn the hand incorrectly. Check against the diagram above.

Middle finger

Index finger

Ring finger

'Pinky'

Finger base

Thumb and 'ham'

Palm and heel

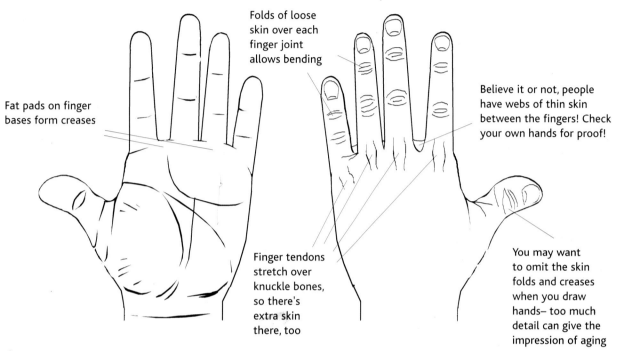

Folds of loose
skin over each
finger joint
allows bending

Fat pads on finger
bases form creases

Believe it or not, people
have webs of thin skin
between the fingers! Check
your own hands for proof!

Finger tendons
stretch over
knuckle bones,
so there's
extra skin
there, too

You may want
to omit the skin
folds and creases
when you draw
hands– too much
detail can give the
impression of aging

Hand movements

Study the illustrations on this page
and consider how the hand and fingers
bend. The thing to remember is that
the hand has two hinges: the hinge
between the ham and the palm, and
the one between the finger base and
the palm. (The palm itself does not
move. These hinges allow the ham and
base to move toward each other
relative to the palm.)

The double joint inside the ham
makes the thumb extremely mobile in
comparison to the rest of the hand. It
is easy to fold the thumb almost 180°
from its extended position – the
famous 'opposable thumb' that makes
human beings the wacky tool-users we
are. Notice that when folded down all
the way, the thumb disappears behind
the hand as seen from the back.

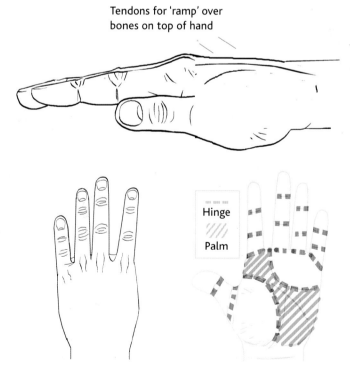

Tendons for 'ramp' over
bones on top of hand

Hinge

Palm

Hands in Motion

Now let's create a hand step-by-step. Keep on practising until you can get it just right every time – and soon you will be able to draw a realistic hand in any position.

 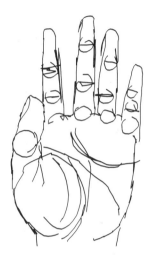 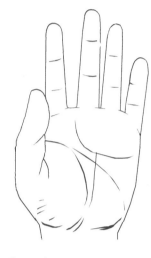

Step 1
Draw the basic 'ironing board' shape shown here. Sketch in the fingers, joints, ham/thumb hinge and finger base hinge.

Step 2
Using a lightbox or tracing paper, start to refine the hand shape. Separate the index finger from the other three fingers.

Step 3
With your own hand as a guide, 'flesh out' the boxy shapes into more natural forms. The fingers should taper to rounded tips.

Step 4
Sketch the hand on to a fresh sheet of paper using a lightbox or tracing paper. Check the relative positions of the joints.

 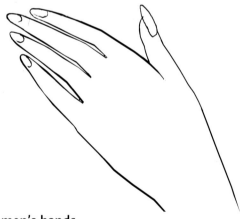

Fists can be tricky, but the thing to remember is that they're just fingers folded over. When folded, the muscle and fat in the fingers are squeezed, making the fingers swell, and the tendons are stretched taut over the knuckles and joints, giving them a knobby effect.

As silly as it sounds, the best way to draw a fist is to make one with your own hand and pretend you're going to punch yourself in the eye – then just draw what you see. (You can also use a mirror if you're afraid of looking weird.) Fists also look different depending upon their aspect: a fist seen from straight on looks different than one seen from below or to the side. Practise drawing them from a variety of angles.

Women's hands
A lady's hand is different from a man's, and should be drawn differently, with fewer details and smoother lines. Women have more subcutaneous fat, so their fingers should be drawn longer, smoother and more tapered than the muscular, blocky fingers of a man. Don't forget the nails: study photographs of manicured hands to get the correct.

Feet

Let's look at feet - how they work and how to draw them. In many ways you can make use of the same principles you just used to learn to draw hands.

Ok, feet. I have known many a working, professional comics artist who couldn't draw feet. Instead, they'd draw the character standing in fog, or wearing floor-dragging flare pants. Well, we are manga artists. No wusses! No lying about in ponds! We will learn to draw feet or we will die trying!

Here's the big secret: the foot is nothing more than an elongated hand,

only with no thumb. Instead, imagine that a thick fifth finger, hinged the same way as the other four, is placed next to them. That's the big toe. Once you have this idea in mind, 85% of the complexity of the foot disappears. Below are ball-and-cylinder drawings of the foot, plus three views, to give you the general layout of this most enigmatic appendage.

▨ Contact Area

The foot has only one hinge between the toes (green area) and the rest of the foot (blue area).

Cat Foot

Leg

Toe

Foot

Heel

Human Foot

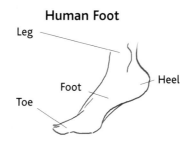

Leg

Toe

Foot

Heel

Animals can be a help when it comes to remembering the parts of the body. A good example is the cat's foot; although the cat walks on its toes, its foot has the same parts as the human foot – only the proportions are different.

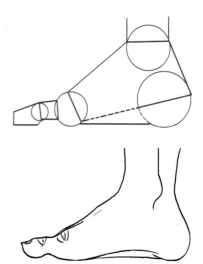

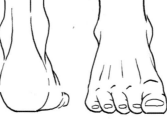

When drawing the foot, keep in mind that, unlike the hand, it is curved. The right foot curves leftwards, towards the centreline of the body, and the left foot curves in the opposite direction.

Also, remember the big toe sits a little bit outboard of the rest of the foot and curves inward; in most people, the other toes curve inwards towards the big toe.

Walking and Running

Your characters need to be able to move towards and away from the action and interact with each other. As such, it's vital to appreciate how we do this ourselves.

Drawing a human being in motion is trickier than you might think. The first thing to keep in mind is that the human body twists with every step. Check it yourself – when a person walks, their pelvis twists as they place one foot in front of the other, and their shoulders and upper body twist in the opposite direction so that the net twist is zero. Another way to visualize this is to realize that the limbs of a person move opposite to each other as they walk. As the right leg moves forward, the right arm swings back, the left leg moves back, and the left arm moves forward to match the right leg.

Centre of gravity

The reason is balance. The body has a centrepoint, called the centre of gravity (CG), which is the point upon which the weight of the body is equal on all sides. (If you were to hang the human body from a sling, the CG is the spot where the sling would connect to the rope; in other words, the CG is the point from which the body would have to be suspended for it to remain in balance.) The thing to remember about the CG is that it must always be supported when the body is standing upright; if it isn't, the person will fall over.

The walk cycle

Walking is really a series of short falls. As you stick out one foot for a step, you temporarily remove the support

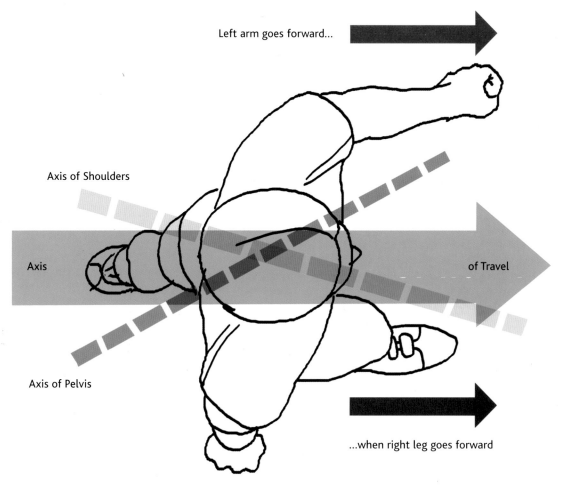

Left arm goes forward...

Axis of Shoulders

Axis

of Travel

Axis of Pelvis

...when right leg goes forward

Body remains
balanced

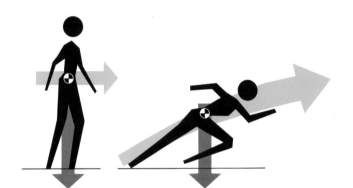

Maintaining the
centre of gravity
during walking and
running. A person
walking stands
upright, but a
person running
must tilt the upper
body forward.

below the CG, and the body begins to topple forward. When the outstretched foot hits the ground, support is restored; the CG continues to move forward with the body as it moves ahead on the planted foot, the rear leg is picked up and moved forward, throwing the body off balance, and the process begins again. This series of movements is called the walk cycle.

The mechanics of the walk cycle were explored in a famous series of photographs taken by 19th-century photographic pioneer Eadweard Muybridge (1830–1904). His photographs demonstrated the nature of human locomotion and the principle of balance (see below). An important thing to remember is that the faster the person's walk becomes, the more off-balance the body becomes at each step. As demonstrated in the illustrations above, a person taking a slow walk stands almost upright; the line between the CG and the supporting foot on the ground is almost vertical with every step. A person in full run, however, throws his or her body far off balance, tilting it forward dramatically and creating a large angle between the CG and the supporting foot. This extreme off-balance condition requires them to swing the opposite leg and foot forward rapidly to keep from falling over.

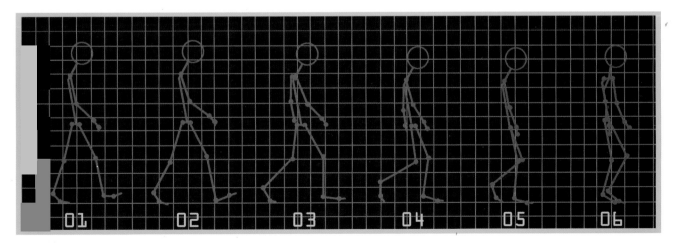

A series of drawings based on the Muybridge photographs illustrate the walk cycle.

Hair

Long hair, short hair, curly or straight – a hairstyle can say a lot about your characters. Here's the fast-track guide to becoming a top hairstylist!

Hair is not a single, solid mass similar to a pudding; neither is it a minutely detailed mass of individual threads, each hanging separately from the others. Hair should be drawn in a way that shows it for what it actually is: a collection of thin strands that cling together with other strands to form thick locks. These radiate from a point on top of the head called the crown. Manga artists further subdivide locks of hair into wisps, which are drawn using thinner lines than those used to draw the locks. By careful use of wisps, it is possible to capture the swing and texture of real hair.

The character of hair

The diagram on the right shows the basic anatomy of a typical hairdo for a woman with straight hair. Most girls and women divide their hair in some manner, usually by separating it into two parts along their natural forward-backward parting. Ladies with neck-length or longer hair also generally arrange their hair into two forelocks, or hair that hangs in front of the ear and the fall (hair that falls down the neck and back from behind the ears). The hair above the forehead is either divided and combed into the forelocks, combed to one side and secured with pin, clip or barrette, or cut short and even across the tips and allowed to fall across the forehead in a fringe. The hair at the crown is generally pulled close to the scalp by the weight of the hair below, and so is usually not drawn too thick.

Anatomy of a Hairdo

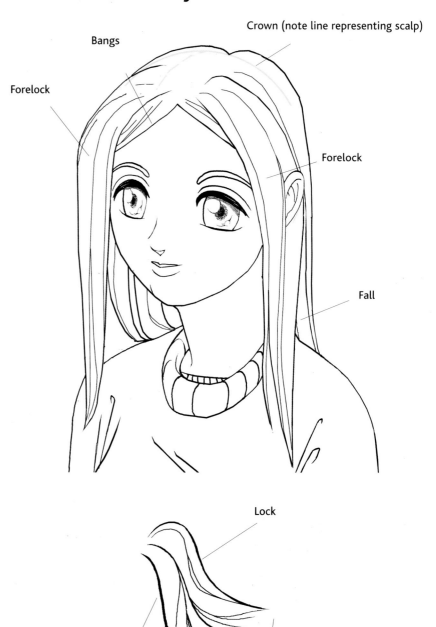

Bangs

Crown (note line representing scalp)

Forelock

Forelock

Fall

Lock

Lock

Wisps

(Hair may be given a thicker appearance by combing it back from a side-to-side parting near the front of the scalp; this process is called 'teasing' or 'ratting' the hair, and hair styled in this manner is called bouffant. At the back, hair may be allowed to hang down, or it may be worn 'up' in a twist (a vertical roll of hair) or a ponytail (hairstyle in which the hair is pulled together and tied at the back of the head). Longer hair may also be worn in braids, either plaits (loosely woven braids) or pigtails (tight braids of hair). Ponytails, pigtails and braids may all be accented by ties, combs, braided-in ribbons, or bows.

One staple of manga is the short hairstyle for girls known as the pageboy or bob. There are four basic styles of the bob (see the diagrams below), which I call the Moni, the Tavi, the Mo and the Aubrey.

Know your Bobs!

A

B

C

D

A The Moni
This is your basic Japanese schoolgirl haircut – medium-length hair cut almost straight across the bottom, with fringe combed to the side.

B The Tavi
Here the hair is cut extremely short at the back, with long forelocks and spiky fringe – a cute 'goth' look.

C The Mo
The basic 'Prince Valiant' cut, forelocks only slightly longer than fall, with short, bowl-cut fringe – good for girls with fine hair.

D The Aubrey
Chin-length or shorter hair with a long fringe, usually held in place with clips – a young, fun look.

Curly and long looks

A

B

C

A The Euro

This is wavy or loosely curled, smooth hair, quite long.

B The Afro

Tightly curled, kinked hair, short and cut close to the head.

C The Isro

Here the hair is medium curled, and smooth, it can be short or longish.

Naturally curly hair can be drawn in three basic ways: the Euro, the Afro and the Isro. The Euro is common to people of European ancestry, the Afro to people of African ethnicity, and the Isro to Mediterranean and Indo-European peoples, but feel free to mix and match!

For reasons of both appeal and practicality, it's not necessary to draw every tiny curl when depicting these hairstyles. Instead, treat the hairdo as a mass, with just enough detail of curl (around the edges, for example) to get the idea across.

Although few women in real life wear their hair longer than the small of the back, characters with super-long, super-dreamy hair are a long-standing tradition in Japanese comics. Artists such as Reiji Matsumoto (*Space Pirate Captain Harlock*, *Space Battleship Yamato*, *Galaxy Express*) often draw their female characters with floor-length or longer tresses to create a romantic, almost fairy-tale appearance. If you choose this style, keep in mind that long hair is heavy; the longer you draw it, the thinner it will look and the shorter it will make your character appear. Characters with long hair need to be tall, willowy and ethereal in appearance to pull off the space-princess look. Also keep in mind that ultra-long hair is not practical for most women; if your character is an astronaut or a submariner, cleaning and grooming a six-foot-long mane is going to present a real problem!

The Manga Eye

In manga the eye is the key communicator of character, from personality type, to mental and emotional state, to age and role in society.

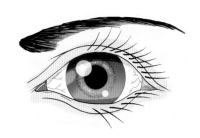

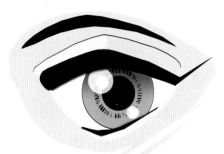

By comparing the more-or-less realistic drawing of an eye on the right with the stylized version on the far right, it's possible to see the kind of abstraction needed to create a good, expressive shonen manga (boys' comics) eye.

Note that the shonen-style eye is significantly larger than the regular eye, but not overly so. It is also much less detailed, making it seem more real to the reader. This is the goal you should be aiming for.

By contrast, the typical eye used in shohjo manga (girls' comics) is drawn a great deal larger than the actual eye would be. This is because much of the information communicated in shohjo manga is communicated via suggestion, intuition and symbolism, rather than in the form of words or depictions of action. The huge, expressive shohjo eye is a true window into the soul of the manga character.

In the two examples shown below you'll notice the extreme sketchiness – even sloppiness – of the drawing. Believe it or not, that's OK! Shohjo manga artists often draw in a deliberately sketchy style in order to give the drawing an organic feel. An eye drawn in a scratchy freehand can be much more expressive than the precise ovals and clear lines of a shonen manga eye.

The eye shown on the right is a dark-coloured eye. Notice the use of crosshatching and highlights to give the impression of depth. Your characters' eyes should show how soulful they are; your 'good' characters should have eyes like liquid pools of feeling.

When drawn from the side, the eye takes on a triangular aspect. Note the lines delineating the fold of the eyelids, the shape of the lashes, and the overall roundess of the eye as seen in profile. Never forget that the eye is a ball.

The eye on the right is an example of a blue eye. Note that the iris and pupil have been shaded using tiny, sketchy half-loops, and how the highlights are only semi-outlined.

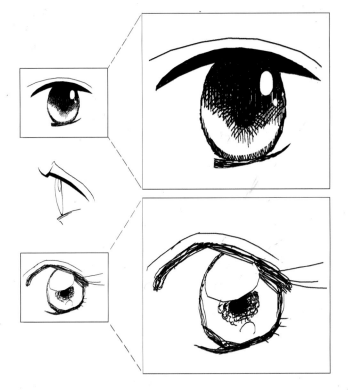

Head Games

To illustrate how powerful hair and eyes are at conveying information about a character, I've duplicated the same head six times and created six visually different characters for a typical robot/war/sci-fi strip using key changes in the hairstyle and eyes.

A The Captain
Small, dark, shining eyes indicate maturity and character; Brylcreemed hair indicates discipline. He longs to return to Earth and to his belle Marie.

B The Kid
Alert, open face and eager expression mark him as the rookie; unsophisticated hair style indicates he's a country boy. The new robot pilot on the block, he's innocent, but not for much longer.

C The Hero
Tousled pompadour? Check. Kabuki brows? Check. Eyes burning with fires of justice? Check. This hero is a sullen loner out for revenge, or vindication, or something. He learns to love while operating the giant robot.

D The Second Fiddle
Sleepy-eyed gaze + smirk = bad boy with a heart of gold. The girls go wild for him, but his only affection is for himself, his giant robot and his best friend/man-crush, the Hero. He dies tragically in the Hero's arms in the next-to-last episode.

E The Player
Hairsprayed hairdo and droopy lower lids mean that this is a guy who's out only for himself. He's always figuring the angles, making deals and operating behind the scenes.

F The Ninja
Silent but deadly. He may be working for the Enemy, or he may be a survivor with a tender heart. He also hides a Terrible Secret. The Ninja doesn't play well with others until the final episode – when he sheds manly tears over the death of the Second Fiddle, covers the Hero's back while he saves the world, and earns the respect of the Captain.

Posing the Figure in Action

When posing your figures in the frame, it's important to keep in mind that body language is as important as the spoken word when it comes to communication.

Many new artists draw stiff figures in stock poses or frame after frame of characters standing with their hands at their side. There's a word for that kind of cartooning, and that word is boring. Don't fall into that trap.

When laying out your manga page, try and think of yourself as a photographer rather than as an illustrator. Grab a book of famous photos or review some on the Web and see how the expert eye of the photographer captures the personality and situation of their subject. What you'll find is that in the best photos the subjects are not looking at the camera; in other words, they are not posing at all. That's the secret to drawing your figures in dynamic and interesting ways: don't so much pose them as capture them in action. Vary your 'camera angles'; feel free to draw people from the back, top and below for variety; and don't be afraid to experiment with off-centre framing, extreme close-ups and other cinematic techniques. (We'll cover this topic in more detail in Chapter 3.)

And now, a word about cheesecake

What is 'cheesecake'? Simply put, cheesecake is a drawing of a pretty girl wearing very little clothing, or in a suggestive pose, or otherwise kitted out in a manner intended to make the lads smile. It's long been a popular subject for garage-wall calendars, tool catalogues, sport magazines and comic books. Manga is no exception.

Please note I'm not talking about pornography. Cheesecake is generally about suggestion, 'innocent' hints and the art of the good-natured tease.

Cheesecake is fun to draw, but its appeal has its own dangers. Aspiring young male manga artists often give in to the temptation to fill their own comics with badly drawn imitations of half-naked manga heroines. This is not only embarrassing, but it can kill your creativity, as energy that should be devoted to storytelling and originality becomes diverted into the creation of ever-more-sexual images.

If you choose to draw cheesecake in your manga, use your common sense and let your conscience be your guide.

Drapery

Don't get in a twist trying to create folds and wrinkles. Follow the B-Chan technique and you'll find out how easy it can be.

A

B

Imagine a piece of string, tied to the top of a pole at one end, with the other end left to hang (A). If the string is long enough, the bottom part will touch the ground, and the string will curve, or drape, from the point of attachment to the point on the ground.

The catenary curve is the natural shape of a flexible object suspended between two supports in a gravitational field, as illustrated in the diagram above (B). The cables of a suspension bridge are a good example of catenary curves.

C

The art of drawing drapery (folds and wrinkles in cloth and other fabrics) is often made out to be more complex than it actually is. Huge volumes have been written describing the minute details of how elbow wrinkles in cheesecloth look or how to draw burlap wrapped around a runny cheese. While I suppose one could benefit from learning drapery skills from such an analytical perspective, we're not going down that route. Instead, we're going to learn how to draw wrinkles and creases the lazy way … the easy way … the B-Chan Way.

In diagrams A and B above you can see the catenary curve which is produced when fabric hangs between support and ground or between two supports. The catenary curve is the key to drawing drapery. By thinking of fabric in terms of catenary curves, you will find that drawing drapery will become much more intuitive. Even a loose piece of cloth forms a catenary

You'll notice that there's quite a bit going on besides catenary curves in the example (C) shown left. Cloth not only drapes, it folds and wrinkles as well. The degree of folding/ wrinkling seen in a piece of fabric depends upon its thickness and stiffness, as well as movements in the objects supporting it.

when blown by the wind; in fact, the ripples that make a flag seem to wave are catenary curves, with the flagpole serving as one support and the wind as the other. Diagram C to the right depicts a piece of cloth being supported by the wind in this way.

Through Thick and Thin

Different fabrics drape differently. Observe and sketch real-life drapery to get a feel for how a fabric's texture and thickness affect the way it drapes and folds.

Many men's suits are cut from worsted wool, a moderately thick and stiff fabric, which drapes heavily from support points and only wrinkles near the joints. Note the wrinkles around the inside of the elbow joints shown right (A). Also notice how I've depicted the thick folds in this sketch – can you spot the catenaries and their support points?

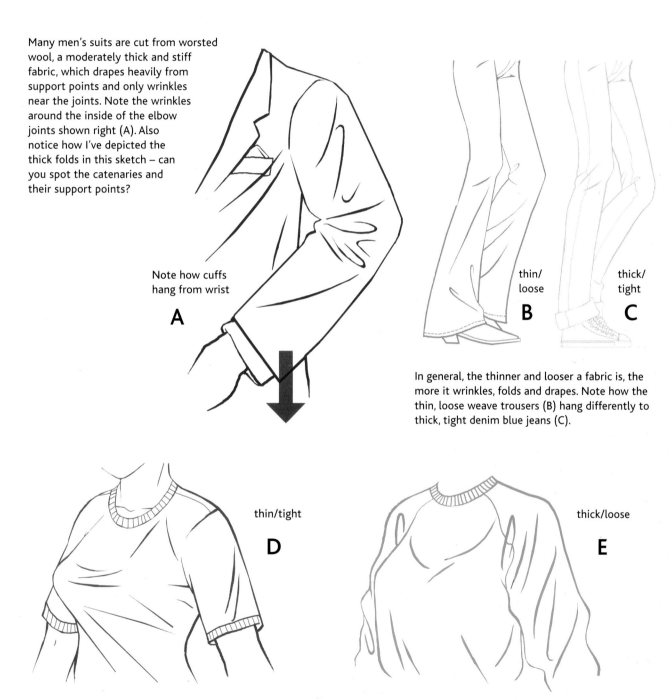

Note how cuffs hang from wrist

A

thin/loose

B

thick/tight

C

In general, the thinner and looser a fabric is, the more it wrinkles, folds and drapes. Note how the thin, loose weave trousers (B) hang differently to thick, tight denim blue jeans (C).

thin/tight

D

thick/loose

E

Thin, tight fabric like the ironed T-shirt shown above left (D) clings to the body and shows much more drapery than a thick, loose garment that hangs from the body like the sweatshirt illustrated above right (E).

Mecha

There are two approaches to drawing mecha (pronounced 'mecca') – mechanical things such as trains, planes, cars, spaceships, robots, etc. The first of these, and the one most often used by serious manga artists, is the 'swipe' method. The second is the 'scratch' method. Read on to find out more.

Swipe is an artistic term for the act of copying some other piece of art – a drawing, photo, etc. – while changing it only enough to prevent legal action.

First, you need to find a photograph of the mecha you wish to draw. In order to legally reproduce a photo, even as a drawing, it's almost always necessary to buy the licence (official permission) to do so from the artist-photographer who took it (or from whomever it is that owns the rights to the image). This can get expensive. Big-time manga artists in Japan often hire their own professional photographers to go out and snap shots of whatever building or aeroplane it is they want to put in their comic book – but this too can be a pricey proposition. The best way to get good photos is to search the library or the Internet for images that are in the public domain (i.e., that are free for anyone to use). Below are three examples of swiped images created from photos for you to study.

The best way to swipe a photo image is to scan or otherwise get it into digital form, then use a design software application like Adobe PhotoShop to digitally trace the outline. Once traced, you simply dump the photo image and add tones and whatever other changes you wish to the digital tracing. Another method is to use a lightbox or light table to trace the outlines with pen. Either way, the swipe is your key to creating really detailed backgrounds and gadgets.

Mecha From Scratch

The other (and perhaps more honest) technique for drawing mecha is the scratch method. Let's look at a step-by-step example.

In the 'scratch' method, you create the drawing from your own imagination (from scratch!) using simple shapes like boxes, cylinders, cones, and curves as the basis for the item you wish to depict. You then add detail and toning as necessary to give the drawing a realistic feel. The scratch method is best when you want to draw something that doesn't exist in the Real World – an imaginary supercar, a mile-high skyscraper, a futuristic fighter jet, a starship, etc. In this example set out below, I've drawn a space fighter being launched from the deck of a space battleship to show you how the scratch method works from initial sketch to final image.

Step 1
The process begins with a sketch – a quick drawing to capture the basic idea and 'feel' of the drawing you want to do. You can make this as messy as you like.

Step 2
Next, create a simplified image of the space fighter – break it down into cones, cylinders, and other simple shapes. Just as the ball-and-cylinder method helps to build a 3-D mental image of a character, this simple sketch will help to think of the vehicle as a 3-D object.

Step 3
From the simplified image create a perspective image of the ship, using accurate cross-sectional ovals, straight lines, and perspective. You can do this digitally, using PhotoShop or similar programs, or manually using oval templates and a straightedge.

Step 4
Once you have the cross-sections and perspective right, you can create a wire frame image of the ship. This will serve as the skeleton of the actual drawing.

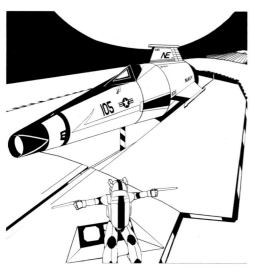

Step 5
Next comes the actual drawing, or line art, which I produce digitally or by light box, tracing over the wire frame image. Add in details, black areas, and background needed to flesh out the picture.

Step 6
The final image is produced by adding shading or colour to the line art. There are several ways to do this, which we'll discuss later in the book.

CHAPTER 3

Creating Manga

You've got the skills, now it's time to put it all together and actually produce something. This chapter tells you how. By following the Seven Steps of Manga, you'll go from blank mind and blank page to actually selling your manga to the public. This is where it all pays off – so let's go!

Organizing a Manga Circle

It takes a special breed of artist to work on his or her own. But a task that seems enormous to one person shrinks to manageable proportions when tackled by a group of like-minded individuals.

'I want to draw manga, but I don't know how to get started.' Over the many years I've spoken to young people about drawing manga, I've learned that the difficulty of getting started is probably the number one problem experienced by prospective artists. Most of these people are bubbling with ideas and energy to spare, but when it comes to actually sitting down and facing that first cold, white, blank sheet of paper, all that bubble and spark just seem to fade away. So how does one get past that first huge hurdle? How does one take the first step in the long walk of manga making? If you are one of those who wonder, this section is for you.

The first thing to realize is that you are not alone. In your city or town there are almost certainly other manga fans (and prospective creators) who share your love of the art form, and who might be willing to join forces with you in exploring its possibilities. By meeting other manga enthusiasts and sharing ideas, encouragement and effort, you can vastly increase the odds of not only starting that manga project, but finishing it.

This is the purpose of the manga circle. A manga circle is a group of artists who join forces to create and publish manga on their own. In Japan, there are thousands of such circles, the vast majority of which are comprised of young people who are not professional artists. These manga circles publish hundreds of thousands of pages of original manga fanzines

(called dohjinshi) every year, and trade and sell them to each other and to the general public. Many of these young artists go on to become successful pros working in the manga industry; others simply enjoy creating and trading dohjinshi 'zines as a hobby. If they can do it, so can you.

Manga circles provide three important benefits to the artist: first, they are a great way of funding the publishing of a manga 'zine; second, they provide a team environment for members to discuss, encourage, critique and motivate each other. Third, they provide artists with an opportunity to set goals and work towards them as a team. This is perhaps the most important, for without specific goals, it is almost certain that an artistic project will become bogged down, sidetracked or otherwise abandoned.

It's simple to form a manga circle. Just ask your manga-loving pals if they're interested in actually putting out a manga. Put up notices on your school, library, college or workplace bulletin boards. Once you have three to five interested friends, pick a day of the week and a time when everyone is free and get together on a regular basis – say every other Saturday at 2 p.m. at your kitchen table.

And if you live out in the country, or there are just not enough manga lovers where you live, don't despair. Get on to the Internet, join an online manga creator's forum, or form one of your own. Stay in contact!

Imo can't sleep. He wants to create his own original manga, but when he thinks about actually doing it – well, it all seems so confusing.

Hope comes in the form of Hana. Imo has posted a notice on a bulletin board at his school stating his desire to find friends who are interested in manga.

The next evening, Imo is surprised to find an invitation in his e-mail inbox. It's from Hana, who invites him to visit her manga circle on the following Saturday afternoon.

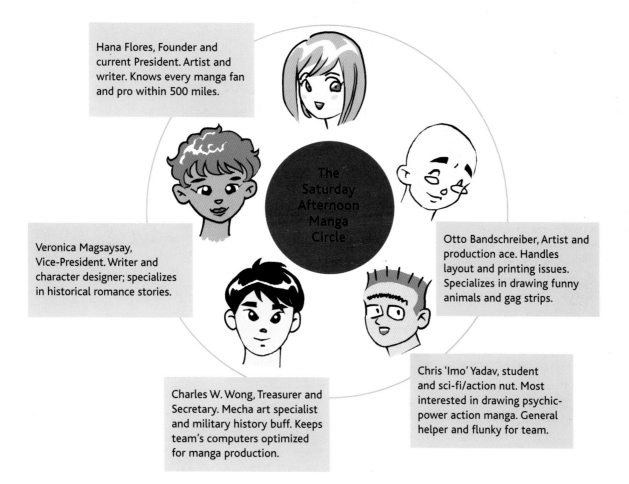

Hana Flores, Founder and current President. Artist and writer. Knows every manga fan and pro within 500 miles.

The Saturday Afternoon Manga Circle

Otto Bandschreiber, Artist and production ace. Handles layout and printing issues. Specializes in drawing funny animals and gag strips.

Veronica Magsaysay, Vice-President. Writer and character designer; specializes in historical romance stories.

Chris 'Imo' Yadav, student and sci-fi/action nut. Most interested in drawing psychic-power action manga. General helper and flunky for team.

Charles W. Wong, Treasurer and Secretary. Mecha art specialist and military history buff. Keeps team's computers optimized for manga production.

Here are a few issues to think about when setting up your manga circle.

Charter and purpose

Write a simple charter, e.g. 'The Saturday Afternoon Manga Circle (SAMC) is an association of friends united to promote, discuss and create manga', and vote on it until it passes by a majority.

Officers

You'll need a few officers. Elect a president (to set the agenda and lead the circle), a vice-president (to help the president) and a treasurer/secretary (to keep track of money and to take notes during meetings).

Subs

You'll need money for materials and later to print and distribute your 'zine.

Take a vote and establish a subscription system early on and collect it by passing a hat or cash box around the table at each meeting. The money can be kept in a bank account if you want to go that far, but a cash box with a lock and key will work just as well. (Leaving the club cash in the care of a trusted adult or a majority-approved third party can also help avoid money troubles.) Try to avoid having arguments over money.

Rules

The fewer, the better. A few simple rules, such as if you miss three meetings, or miss paying subs three times, the club can vote you out, are all that are needed for a small circle of friends. Just treat the others as you'd like them to treat you and you'll find the need for rules quite small.

Meetings

Order a couple of pizzas or some Chinese food, but wait until after the business is over to eat – this will encourage you all to be brief and to the point during the meeting. At meetings, the president calls the group to order, the vice-president announces the agenda, the secretary/treasurer takes notes, collects the subs and reports on the finances, and the circle as a whole votes on specific issues at hand. Use your meeting's business time to set goals, make schedules, review member contributions and generally get down to the hard work of drawing your manga. When finished, the vice-president moves to adjourn, somebody seconds and, upon a majority vote, the president closes the business portion of the meeting. Pizza time!

Creating Good Stories

Storytelling is crucial to manga. In fact, it's more important than the art! A good story with bad art can make for worthwhile reading, but a bad story is unreadable no matter how good the art is.

Here are some tips for creating good story ideas. (We'll discuss the dramatic techniques of good storytelling later; this section is strictly about coming up with initial story ideas.)

Some people are blessed with a mental treasure chest of good stories. For others, it's a struggle to come up with an interesting plot. No matter which kind of person you are, however, it's a certainty that at some point you're going to be hit by a sudden flash of inspiration – a brilliant idea for a story that unexpectedly zaps into your mind like a mental lightning bolt. When inspiration hits, I stongly suggest that you jot down the details ASAP; such bolts from the blue are few and far between.

On the other end of the creative spectrum are those moments when you simply cannot come up with a story you like, no matter how hard you try. You toy with various ideas, but they all seem stupid ... your drawing hand seems stiff and incapable of producing

The flash of sudden inspiration can be exciting – but also shocking...

a straight line. What's going on? Friend, you've been crushed by the dreaded creative block – a state of being during which creative ideas just won't flow.

Most manga creators do not live by the inspirational shock or dread the creative block. Instead, many use a stream of consciousness approach. 'Gee', they think, 'I'd like to do a sports manga. But which sport?' They then

...but it sure beats the heck out of being crushed under the Creative Block.

flip through the sports section of the paper, watch a sports channel on TV, or head out to the golf course and wait for ideas to occur. Let's look at how the creative process might run: say that while driving by a school tennis court, the thought of doing a tennis manga occurs to our artist. This leads to thoughts of tennis players... women tennis stars... teenage girl tennis aces in short skirts... teenage girl tennis stars of Russian ancestry living in the USA in short skirts... Maria Sharapova...hey, what if she were Russian royalty and didn't know it, and suddenly, just before Wimbledon, Russia decides to restore the monarchy, and – wow, Maria Sharapova, er, Romanov, last heir to the Czars, is forced to choose between the game she loves and the Throne of Russia! Yeah, that's the ticket!

And so a story is born: let's call it, 'Aim For the Crown'. I'd read it!

If the story you want to do seems like it's been done before, don't worry, because it has. Just remember: 'What has been is what will be, and what has been done is what willl be done; and there is nothing new under the sun.'
(Ecclesiastes 1:9)

Four Story-Generating Methods

If you're really stuck for a story idea, try one of these methods. They may look simple, but believe me, they really do work.

The Golden Oldie Method

History, mythology and folklore, reflecting universal themes and values, are a great treasure chest of story ideas. (Most classic tales are in the public domain as well!) Try updating your favourite myth or legend by changing the setting to the inner city (à la West Side Story) or outer space (à la 2001: A Space Odyssey) – it's easy and fun!

The True Stories Method

Remember the first time you asked a guy or gal out on a date? How about the track meet where you won that 500-metre dash by really giving it your best? Real-life tragedies and triumphs will resonate with your readers – after all, everybody's had the same kind of experiences. If you keep a diary or journal, use it as a rich source of great true-life stories.

The Title-Bashing Method

With your friends, jot down 30 random words on slips of paper. Ten should be names, 10 should be adjectives, and 10 nouns. Drop them into three containers. Each person draws a card from each container to form a title, such as 'Crispy Soldier Melvin'.

The Shameless Swipe Method

Let's say you're a big fan of a certain sci-fi TV show (let's call it Startrack) featuring a bold, dynamic, young captain (we'll call him Captain K) and his stoic, alien first officer (Mr S). You could spend hours creating a fan-fiction story about their exploits, but under current copyright law you would not be able to sell your Startrack manga (or even distribute it for free!) without risking legal action by the owners of Startrack. Instead, you could create an original story that is remarkably like Startrack in many ways. As long as your characters are similar but not identical to those owned by the producers of Startrack, there can be no violation of copyright.

Workspace

Finding a comfortable place to start working on your project is important. For me, the good old kitchen table is best!

Creating manga should be a joy, not a chore. (We'll get to the chores later.) As such, it's important that you find a place to do your creating where you'll be comfortable, relaxed and close to food and restroom facilities. (Hey, let's be real here, okay?) For me, the place that best fits these criteria is the kitchen table in my home.

I've been drawing at the kitchen table since I was a lad. It was at my family's kitchen table that I created the first comic strip I ever submitted to a 'real' publisher (*Boy's Life* magazine, 1975, rejected – but in a kindly way – by the magazine's editor). As a college student, I drew my first fanzines and comics at a shared kitchen table, I drew the sketches for my first commercially-sold illustrations at mine and my wife's kitchen table, and I drew the roughs for my first complete graphic novel at that very same table as well. In fact, the illustrations you see in this book were first sketched out in the same place my dinner plate usually sits.

Why? Simple. At the kitchen table, I'm not in my workspace (the studio), I'm in my family space (the kitchen). Despite its comforts, my studio is a place of focus and solitude; the kitchen is part of my home, a communal area, a place for rest and refreshment. There the ideas and talk flow easily and freely; I can have some tea or wine, tap into the fridge and enjoy conversation with Mrs B-Chan or a friend or neighbour while I work. I have found that this casual, laid back environment

Mo-Chan
(Mrs B Chan)

B-Chan
(note pyjamas)

Baguette

Hot tea
(Gemnai-cha)

Shiro
Neko

Patchy Neko

Kowaii
Neko

helps me to relax, and a relaxed mind is a creative mind. (More on this subject on pages 84-85.) Therefore, I prefer to do the early, conceptual work for my projects at the kitchen table, where I feel calm, contented and at home.

Your mileage may vary, of course. For some people, the noise, crumbs, and aromas of kitchen life may be distracting, leading them to seek out the silence of their local library as a starting point; others may prefer the noise and laughter of a local bar or café as a place to create, sitting with

sketchpad in hand and doodling new ideas while watching the world go by. The important thing is that you pick a place to start your manga project that is comfortable and convenient. Nothing kills creativity faster than sitting down formally at that cold drawing table and facing a blank sheet of paper. Find a place that's best for you and start your comics project there.

Once you have your basic ideas down on paper, you are going to need a studio – somewhere to complete the artwork and polish it to perfection.

The Studio

This is a classic example of a studio workspace. It doesn't necessarily have to be a separate room, but it should be a space dedicated to your work. Beginners should build up the items gradually.

Reference library

Filing trays

Drawing paper

Desk lamp

Monitor

Window

Work station lamp

Bulletin board

AM/FM/
Shortwave radio

Curtain

Filing cabinet

Snack

First aid kit

Desk

Office
chair

Digital
tablet
and
stylus

Computer

Recyclables
bin

Wastebasket

Lightbox

Personal effects box

Storage
crates

Scanner

Stool

Drawing table

Tools and Equipment

Don't be fooled by other art instruction books. It doesn't take a lot of expensive stuff to get started making manga. A few simple tools are all you really need!

Let's demistify one thing right up front: art supplies, as such, are not needed to draw comics. I have drawn most of my pro comic books with common office-supply type materials – ordinary pencils, ordinary paper, ordinary markers – plus a few specialized (but inexpensive) tools. If you have big bucks and want to impress, go ahead and splurge for the fancy stuff, but if you're a serious beginner (or a thrifty pro!) there's absolutely nothing wrong with using commonly available tools and supplies. Why pay more?

Pencils and markers

For doodles, roughs and sketches I recommend two types of pencil: the disposable mechanical pencil, available in packs of 20 at the stationers'; and the leadholder or drafting pencil, which is a pencil-sized metal barrel with internal spring-loaded jaws that is designed to hold (and be refillable with) consumable pencil leads. Mechanical pencils require no sharpening; if you go with the leadholder, you'll also need to get a box of leads and a special kind of sharpener called a lead pointer to keep the tip pointed and contain its powdered-graphite shavings. The important thing is to use a pencil with a fairly hard lead that can create a smooth, dark line. I advise against using ordinary school pencils, so-called artist's pencils, or non-reproducing blue pencils due to their expense, shavings and often-waxy leads.

There are many kinds of markers, few of which are useful for comics work due to their ink, which is not dark enough and which fades quickly under ambient light. Expensive art-store 'design markers' are ideal for drawing, but are also highly expensive, especially considering how fast they run out. The four markers shown here are examples of cheap, office-supply markers that have performed well for me in actual use; you will, of course, want to experiment with different markers until you find those that suit your work

Typical mechanical pencil. Disposable.

Leadholder. Note pushbutton release, metal barrel, knurled grip, and clamping jaws, plus Berol #2375 Turquoise Drawing Lead, 2mm x 12

Disposable technichal pen, 0.2 tip.

Flexible-tip drawing pen with waterpoof ink.

Fibre-tip ultra-fine-line marker.

Fibre-tip fine-line marker.

habits. Generally speaking, it's desirable to have four types of marker: a technical pen (the disposable ones are fine – get one with a 0.2 tip); a drawing pen with flexible plastic tip (the Japanese ones are great – make sure the ink is waterproof!); an ultra-fine-point permanent marker; and a fine-point permanent marker. These markers are useful for drawing fine lines, doing rough sketches, stippling, crosshatching – any kind of linework where single-width lines are OK. (More on line drawing later.)

Pens

Pens (sometimes called a 'dip pen' or 'nib pen') are the main tool of the manga artist because they produce a line that varies in width depending upon the user's pressure and positioning of the nib, and because they use a dark ink that reproduces well. To use them, first you must prepare the nib (see page 91), then secure it into the circular slot at the top of the barrel, dip it in ink and draw. The three best nibs I've found are the Crowquill nib, used for light, feathery lines; the G-Pen nib, a Japanese nib useful for almost all types of linework; and the shuji or school nib, which makes a slightly thinner line than the G-pen. An astonishing variety of nibs exist, so try a selection of them until you find the ones that you prefer. At the inking stage of your manga art it is also useful to have a correction pen, filled with opaque white paint, to fix errors.

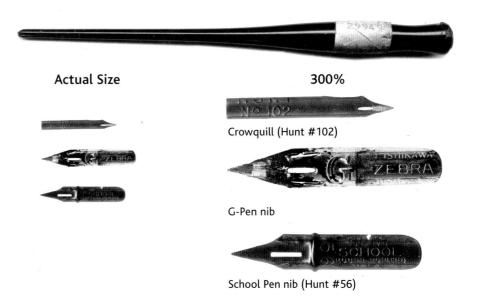

Actual Size **300%**

Crowquill (Hunt #102)

G-Pen nib

School Pen nib (Hunt #56)

Basic equipment

When you boil it down to basics, all you really need to draw manga (or any other kind of comics) are three things: paper, a pencil and a pen of some kind. All of these can be acquired very inexpensively at your neighbourhood office supply store, or stationers, or newsagents.

Pens and pencils have already been covered, but paper is just as easy to get hold of. Just use ordinary typing paper or copy paper, #20 bond, A4 size. This paper is sturdy, recyclable and easy to find. Use it for all your manga pencil drawing right up to the manuscript stage. You'll also want an ordinary office stapler and staples (for attaching rough sketches to clean sheets of paper), a kneaded rubber eraser (for tidying up rough sketches) and a plastic eraser (for tidying up finished art).

Other equipment

Other tools you are going to need to produce your manga projects include a lightbox or light-table; a roll of drafting tape (not masking tape or Sellotape), useful for securing drawings to the lightbox; at least one triangle (I suggest a 30°-60°-90° triangle made of transparent plastic); and a straightedge (I suggest a steel or transparent plastic one of at least 18in./45cm length with imperial units on one side and metric on the other). Make sure your triangle and straightedge have a bevelled edge so that the ink will not 'bleed' underneath when you are drawing straight lines.

Finally, you are going to need to have access to a photocopy machine or instant-printing shop. These are everywhere, so I expect you'll know of several within an easy walk or drive of your studio.

The Character Sheet

You've done your preparation. Now it's time to move on to the pre-production stage by working up a character sheet and a gang shot as reference for your emerging artwork.

It's common in animation production to create both character sheets for each character and a gang shot, or cast picture, showing them all together, which helps the artist keep the characters' size relationships straight.

The character sheet

One of the biggest problems for beginning artists is that of consistency. It's important that each of your characters looks the same from panel to panel and page to page.

The best way to keep them consistent is to create a character or model sheet for each one showing various views and listing pertinent data (hair/eye colour, height, weight). Use them to determine when your drawings are off model (drawn inconsistently) and to establish how to fix them.

The gang shot

The way I build a gang shot is to start with a grid, on paper or in my computer. It should be demarcated bottom to top in units of length (I use inches) with gridlines of a very light colour. Then I take the various character sheets, shrink them one by one (either on the computer or by photocopying them) and paste them (digitally or physically) on to the grid background, making sure to size them according to their height, using the grid as a reference. On the opposite page I have created a gang shot that includes a selection of typical manga character types – vital for creating a well-balanced and interesting cast.

The character sheet should show (at the very least) the face from the front, side and oblique angles, plus a full-length frontal view, a couple of sketches showing the character in typical emotional stages (laughing, shouting, etc.). In this sheet for Sir Allan I've also included a chibi version. (The terms 'chibi' and/or 'super deformed' mean a cartoonish, childlike, small, cute version of a character.)

The Gang Shot

Once you have all of your character sheets done, it's helpful to put them together so you can see how they relate to one another.

The Muscle
Hulking, brutish character with young teen appeal. Giving him a tragic past or a soft heart makes for extra punch.

The Reader Identification Character
The central character that your reader 'inhabits' during the story. Make him/her heroic and virtuous or cold and callous as the story warrants.

The Eminence Grise
Whether grandpa or grandma, this character serves as both moral voice and source of ironic comedy relief. Minor personal foibles such as sarcasm, fondness for drink, or overt interest in opposite (and younger) sex are vital.

The Nerd
A brainy anorak with annoying personal habits. Useful for last-minute disease cures and nuclear reactor repairs. Draw them in such a way that they are good-looking without glasses so that they can get together with one of the secondary characters at the story's end.

The Laurel and Hardy Team
A pair of robots, aliens, or other hard-to-offend types who will offer comedy relief for the reader in the Laurel and Hardy mode.

The Hero
Should be tall, beauteous and just a little bit wicked in the tradition of Han Solo. Usually dies heroically or gets married and moves away by the end of the story.

The Cute Girl
Slender, charming character with lots of appeal for the older boys. Giving her a tragic past or a feisty demeanour makes for extra zing.

The Kid Sibling
A little brother or sister ups the cuteness factor and allows rough-hewn heroes a chance to look like big, protective guys. His/her wide-eyed innocence may be contrasted with other characters' cynicism.

The Ship
... school, or caravan, or secret volcano fortess, or wherever your characters call home. It should have room for all characters plus episodic special guest stars.

The Mascot
Cute animal sidekick. Most important role: possible big-bucks merchandising icon. Kid/teenage girl-friendly mascot = $ucce$$.

Set Design

This is not a book on perspective. This is a book about comics. So here is a brief overview of perspective drawing as it applies to creating manga and nothing more.

A matter of perspective

Perspective drawing is the technique of depicting depth on a flat surface (e.g. the manga page). This effect is created by distorting the shapes of the objects you draw in such a way as to mimic the way the eye perceives depth in real life. In real life, objects in 3-D space appear to narrow in shape and grow smaller in size the further from the eye they are. This narrowing and shrinking is directed towards a single point in the distance, the vanishing point, at which distance a given object becomes so small and narrow as to vanish from sight. Objects at such a distance are said to be on the viewer's horizon – the distance at which the viewer's sightlines are interrupted by the curve of the earth. The horizon forms an imaginary line, the eyeline, which corresponds to the height of the viewer's eye above the surface upon which he or she is standing.

In order to draw an object in perspective, first establish the eyeline from which it will be seen, then the vanishing point (VP) on that eyeline towards which it will appear to vanish.

There are three basic types of perspective: one-point, two-point and three-point perspective. In one-point perspective, the object 'vanishes' towards a single VP; in two-point perspective, it vanishes towards two VPs; and three-point perspective – well, you figure it out. (See the diagram above right for help.) Bad perspective has ruined many a manga. Your readers will immediately notice any mistakes in perspective drawing. So take the time to establish those VPs correctly.

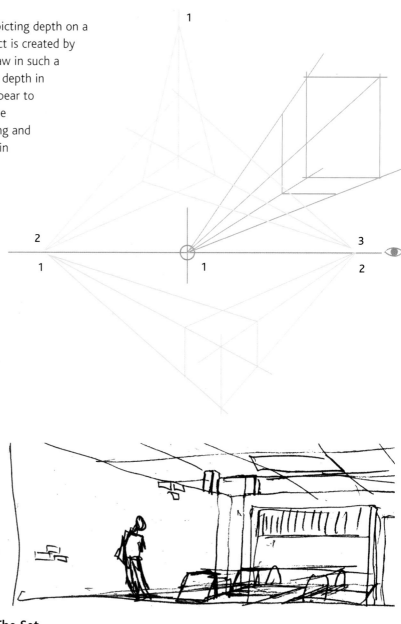

The Set

The set – usually an interior – is where the action of your manga occurs. To give it a sense of space, you must draw it using perspective techniques. First, draw a rough sketch. Establish an eyeline (height of the 'camera eye') and rough in the perspective using construction lines to vanish your objects towards the VPs.

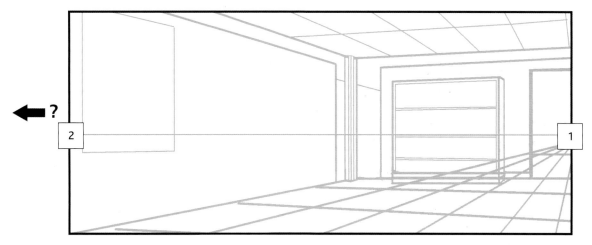

Fake Two-Point

The average interior is best drawn in two-point perspective. But there is a problem: where to put the two VPs? The closer one VP is to the other the more distorted the edges of each object will be when drawn in correct perspective. Since the average person has a field of view about 70° wide, it would require a huge sheet of paper to accurately place both the VPs in relation to one another. Apart from taking up a lot of room, it is also very difficult to work across such huge areas.

Solution: I fake it. I place one VP (1) on the page and the other one (2) way off the page. But I obviously only draw the one on the page; the other VP I just sort of mentally place 'out there' and use my best judgment as to how the construction lines will go. (This takes a bit of practice to get right.) To actually make the drawing, I place my rough sketch on the lightbox and draw in the walls, ceiling and floor in correct perspective using a straightedge.

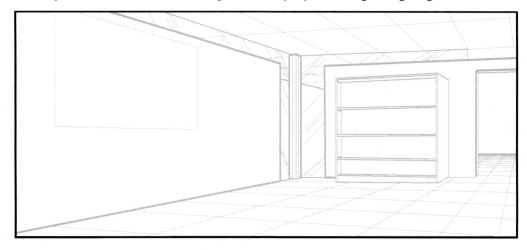

Cleanup

Once I have the linework drawn in correct perspective, I place the drawing on the lightbox and then trace it using a straightedge, this time omitting the construction lines.

From here, you can dress the drawing by adding in furniture, characters and other detail as desired. (You may want to set a copy of the undressed drawing aside to use as a stock shot.)

Giving Good Props

Properties, or 'props', are inanimate non-character objects that your characters use during the course of the action. It's important to learn to draw them well. Here are some tips.

Tip

It's a tenet of manga artists to reference their prop art – in other words, instead of just drawing a generic gun in the Mighty Marvel Manner, it's the manga way to draw a specific gun – in this case a Glock 18. To draw specific guns, cars, kitchen equipment and so forth you'll need to have access to reference material, both printed books and online graphics. Make a point of building a decent library of such materials, or at least know where you can get them, before you begin.

Block by block

Even the most complex objects can be visualized as a collection of simple forms – cones, cylinders, spheres and blocks. Therefore, the key to drawing any object, from a car to a cargo jet, is to mentally break it down into such simple forms. One of the most common props in action/adventure, crime and sci-fi manga is the handgun or pistol, so let's draw one using this technique.

Step 1

First, I pick out the type of gun I want to draw (such as the Glock 18), then, using a photograph of the gun as reference, I rough out its basic form using simple shapes – boxes in this case. (Remember that the rules of perspective apply when drawing these construction lines!)

Step 2

Using a lightbox, I redraw the boxes into the more detailed shapes of the actual handgun, carefully referring to my reference photograph to make sure I get the shapes right.

Step 3

Finally, I once again lightbox a new drawing of the gun, this time drawing in the various nuts and bolts, contour lines and other small details. Voilá, the gun is, er, drawn.

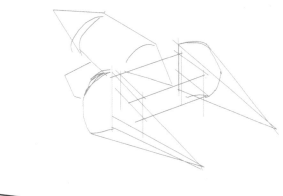

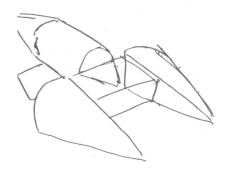

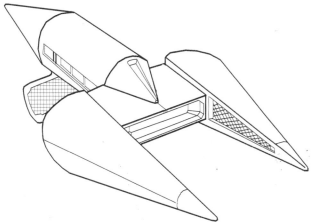

Imaginary props

Even imaginary objects can be drawn using this method. The futuristic stun-gun I've drawn here began as a rough sketch of a bunch of cones, blocks and cylinders, which I refined by tracing it on the lightbox until I had the shape I was looking for. I then lightboxed the drawing again, adding in the details that make futuristic stun-guns so much fun to draw. Make sure you keep copies of your prop drawings so that you can draw the same objects the same way later in the book.

A world of props

Props are the furniture of your imaginary reality; they bring it to life and give it believability. The spaces we inhabit in the Real World are filled with props, and the spaces your characters inhabit should have them, too. By using your props carefully, you can even make them speak – just as the food jars, small change and dog collars the doomed people of Pompeii left us speak to us today. Don't draw your characters in a silent world; make that world speak by using props properly.

Research

Avoid trying to be too ambitious with your stories. Either do your research thoroughly or simply stick to what you know.

One mistake a lot of beginner manga artists make is trying to write *War and Peace* the first time out. In other words, they try to create manga stories set in colourful historic times, complex fantasy worlds, or high-tech wonderlands. The problem with this is that it's easy to get the details wrong. For example, let's say you're doing a historical drama about a soldier in Napoleon's day. You may be the best figure artist and dialogue writer in the world, but if you happen to get the number of buttons on a Napoleonic general's coat wrong, and your reader happens to be a Napoleonic history buff, he or she is going to notice right away. Bam! Suddenly their interest in your story plummets, all because you miscounted the buttons!

Now, one day technology may allow us to build spaceships that use artificial gravity to propel themselves, and it is even possible that such ships could perform 180° turns in space. Unfortunately, Imo's science fiction story is set in a near-future time where spaceships are still propelled by ordinary rocket engines, which can only move ships into and out of various elliptical orbital paths. Uh oh.

Imo's right at the big space battle scene in his sci-fi manga story, but he's not sure exactly what sort of manoeuvres his hero's futuristic spaceship might be able to do. Since it's late, rather than do the research, he decides to fake it and draws the ship making a cool 180° turn before destroying the enemy.

Sadly, Imo's manga has been purchased by a certain Mr Anorak, self-styled science expert (actual science education = none) and Internet manga nitpicker extraordinaire. Mr Anorak is scandalized by the 'bad science' in Imo's story and sets out to warn his friends about the book...

...and a scathing review of Imo's manga flashes across the Internet for all the world to read. Many potential readers take Mr Anorak's opinions seriously, leaving Imo with egg on his face and poor prospects for further sales. How can Imo avoid this sort of embarrassment in the future?

Go with what you know

Imo has three choices: he can continue to fake it (and risk further ridicule), do the research necessary to get the science details right (and risk exhaustion), or write stories based upon the world we live in every day.

I find the third choice to be by far the most practical. I don't write manga stories about typical Japanese teenagers because I know practically nothing about what life is like for the typical Japanese teenager; instead I write stories based upon my own life experiences – school, military service, sports and so forth. I think it's best that the beginner manga artist (and yes, I mean you) starts off simply – by doing stories based upon his or her own life experiences as well. Go with what you know!

...In order to do that, however, you need to have some life experiences – in other words, you need to get a life. So my advice is to get out there and live! Jump out of that chair, turn off that computer, put down that pencil and go off snowboarding in Colorado... or help your neighbour weed her garden... or cook a stew... or whatever. There are a million things in this wonderful world you can do. You can travel! You can see Paris in the spring! You can learn to dance, go skating, visit the sick, volunteer at a community shelter, learn a trade, meet someone new...

or even fall in love...

The Next Big Step . . .

Pre-production is over. Get yourself set up and gather together all the equipment you'll need – it's time to draw your manga.

Production

You've got your story in mind. You've designed your characters. You've roughed out the world they live in. You've got your mecha design ideas going, and you've done your homework to make sure it all fits together well.

You are ready to move on to the next stage: Production.

Over the next few pages we'll go over the process of actually creating the art for your manga. First, we'll lay out the pages, then we'll put the characters through their paces, adding in whatever cool ideas appear along the way. Finally, we'll take a look at a few of the most common art mistakes. All this done well and the manuscript – the flesh and blood of your manga – will appear. Let's get to it!

Beginning To Draw

First you need to create a rough book in which to map out your panel borders – these form the skeleton of your story.

The rough book

First, take three sheets of regular A4 copier paper, (see also page 88), fold each in half, then stack the sheets atop one another, creases aligned. Presto, you have a digest-sized booklet of 12 pages. This booklet is called the rough book, and it's the basis of the manga you're going to create. In pencil, mark the corners of each page of the rough book as follows: the four cover pages FC (front cover), IFC (inside front cover), IBC (inside back cover) and BC (back cover), and the eight interior pages, or guts. Upon these pages you'll pencil in the rough layouts that will, in time, become your story.

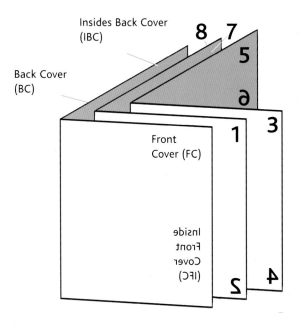

Typical Rough Book – 3 Sheets

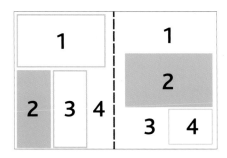

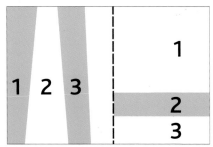

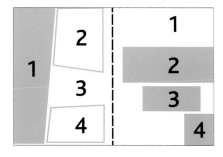

Starting on page 1 of your booklet's guts (although note that these illustrations show spreads, i.e. two pages at once) begin sketching the opening panels of your story. Don't worry about making straight lines, drawing the figures exactly right, or correct perspective. You can fix all those things later. For now, just get those ideas down on paper!

As you sketch, draw the panel borders in roughly, but don't get too fancy – simple rectangular shapes or trapezoids are fine, always keeping in mind the overall balance of the two-page spread as a whole.

Don't tighten up, overthink your art, or get too detailed with these sketches. Right now you're experimenting, trying out viewing angles and, of course, erasing when necessary. Think of yourself as the director of a film, with each panel being a separate shot. By thinking in terms of spreads and shots, you will immediately begin to produce visually interesting comics pages.

Layout Skills

How you lay out the boxes on your page will help your reader interpret what's going on in the story – while boxes of different shapes convey different meanings.

Manga, like all comics, is essentially nothing more than a bunch of pages covered with tiny boxes with pictures in them. Layout is the process of drawing those boxes in the way that best suits their contents, and arranging those tiny pictures on the manga pages so that they flow (i.e. so that they are easy to follow in sequence). But here a hidden enemy lurks – the enemy called boring layout. A lot of good manga soldiers have been lost in the battle, artists who could draw well, but who stuck their beautiful drawings into a grid full of boring, postage-stamp-sized squares. The famous nine-panel grid of Western comics is the enemy of manga storytelling – so fight it! Don't just draw boring boxes. Use the shapes and arrangement of panels on the spread to help tell your story, and don't try to squeeze too many on to the page!

Laying out your work can be a daunting prospect. It is important to consider the story you are telling, rather than simply viewing your task as one long storyboard of endless spreads. By injecting some creativity and a dose of inspired thinking into the mix you can do something different with your creation, and make it all your own.

As a manga artist, your goal is to tell the story using visual images, including panel borders, panel shapes and even the page itself. (American comics master Will Eisner refers to the page as 'the meta-panel'; in other words, as the panel that contains all other panels.) It's important to think in terms of spreads. As you sketch, keep in mind the relationship of panels to each other and to the spread.

If you imagine yourself as a cinema director, it's easy to think of each two-page spread as a scene within your 'film', and each frame within that spread as a shot within the scene. However, movies are by nature motion pictures; comics (including manga) are a medium of static images. Since you can't track, pan, zoom, or pull your shots as a cinematographer can, you're going to have to use other visual cues to suggest motion, mood and milieu, by using panel shapes and placements wisely.

For example: let's say you're doing a scene where your character is revealing an embarrassing secret to a friend. It's just a conversation, sure, but one fraught with plenty of tension. You can express that tension by drawing the panels in edgy shapes such as the ones shown here. The sharp corners and off-kilter lines of the panel borders give the impression of unease and discomfort.

Or let's say you're doing the big breakup scene where Character A is breaking the bad news to Character B. You might choose to express Character B's feelings of surprise and shock by 'shattering' your page into a series of 'falling' panels, such as the ones shown here. Even with nothing in them, the panels of this page give the impression of things going downhill.

I call this the Braveheart Shot: the big two-page panel with the majestic view. It serves the same function as the wide-screen shot in the movies: to convey a sense of majesty, poignancy, or otherwise depict the Big Picture. (Just imagine the end credits of a movie rolling over the image and you'll get the idea.) While the Braveheart Shot is cool, it should only be used very sparingly, lest your manga become an album of beauty shots instead of a story.

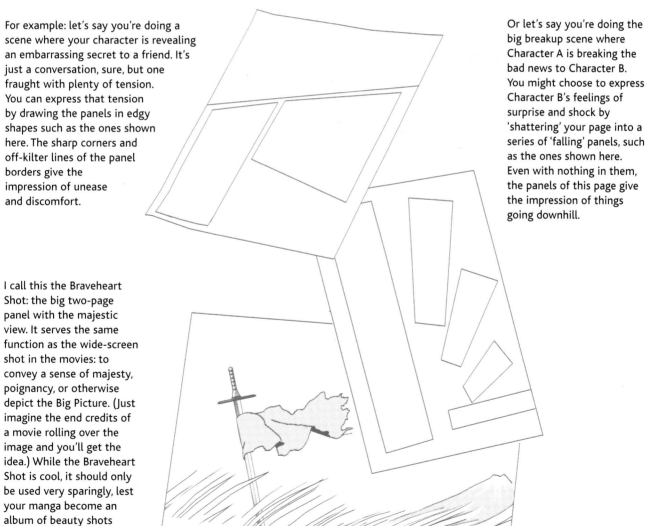

Serendipity: Breaking the Creative Block

You've got your pencil roughs started and things are chugging along nicely, when suddenly, wham, the creative juices dry up. Serendipity may hold the answer to breaking the block.

Serendipity refers to the process of finding useful things by accident, or in rather unexpected places. This lesson is about finding solutions to creative problems by 'accidentally' stumbling upon them, although (as we shall see) the process isn't quite as accidental as it may seem on the surface.

Speaking of surfaces, the science boys tell us that only 10% of the average iceberg shows above the ocean's surface, with the other 90% submerged and invisible. The creative mind is similar. The human mind manifests in two distinct modes: the conscious mind, which is the rational, controlling, thinking mode of the mind, and the irrational, chaotic, unconscious mind, which processes information on a level 'below' the level of thought.

The subconscious

When you consider the sheer amount of data the mind has to process, the percentage of the human mind needed to deal rationally with thoughts, actions and the Real World (i.e. the conscious mind) seems to be too small; therefore, there must be some greater percentage of the mind that operates outside of waking thought – the unconscious mind – that handles the tumble of irrational emotions, forbidden desires and old TV commercials. But how exactly does the unconscious mind do this?

My guess is that the unconscious mind is a sort of mental centrifuge that takes in the whole mad whirl of uncorrelated (chaotic and meaningless) data, and sorts, shuffles and separates this mess until it is formed into neat piles, then feeds the now correlated data back to the conscious mind as

needed, in the form of rational concepts. In other words, I think the subconscious mind is the part of the mind that takes in the aspects of life that just don't make sense and sorts them all out until they have some kind of meaning. The mechanisms used to do this are unconscious thoughts, fantasies and dreams.

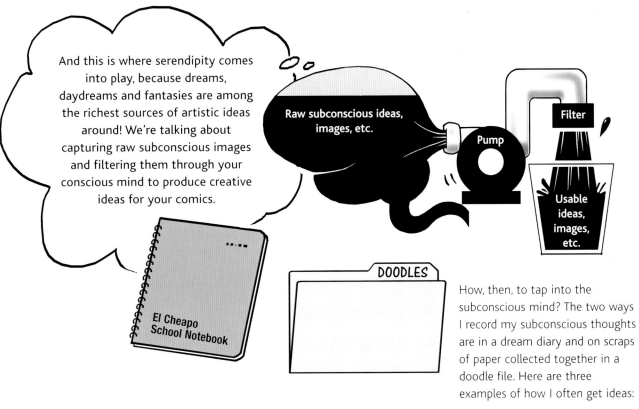

And this is where serendipity comes into play, because dreams, daydreams and fantasies are among the richest sources of artistic ideas around! We're talking about capturing raw subconscious images and filtering them through your conscious mind to produce creative ideas for your comics.

El Cheapo School Notebook

Raw subconscious ideas, images, etc.

Pump

Filter

Usable ideas, images, etc.

DOODLES

How, then, to tap into the subconscious mind? The two ways I record my subconscious thoughts are in a dream diary and on scraps of paper collected together in a doodle file. Here are three examples of how I often get ideas:

Telephone Line
On the phone my conscious mind is focused on listening – but my unconscious mind is silently cranking away in the background By picking up a pencil and notepad, I hook my subconscious to the Real World by way of doodles. I have come up with tons of ideas in this way.

Shower Power
There's nothing like a nice, hot shower for putting the conscious mind on hold and letting the unconscious kick in. I can't tell you how many great ideas for stories I've come up with in the shower! Obviously take notes down after you towel off.

Commuter Autopilot
Boredom can actually be a creative force! This is nowhere more evident than when travelling. The stuffy discomfort of commuting is very amenable to day dreaming. Why not keep a notepad handy on the train, tram or bus (not when you drive, for obvious reasons!).

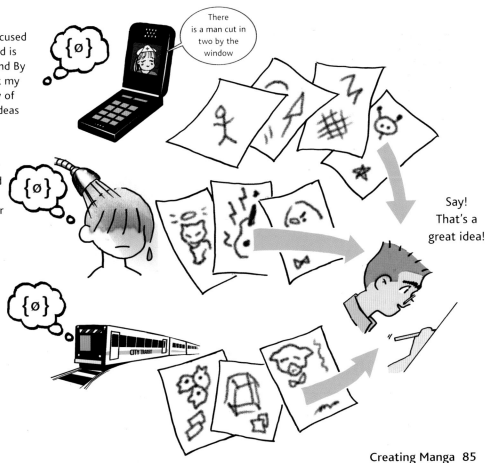

There is a man cut in two by the window

Say! That's a great idea!

Common Mistakes: Peanut Head

As you start to design your pages take care that you don't slip into any of these bad habits of style and layout.

As you continue along in the drawing process, it's easy for mistakes and bad practices to creep in around the edges. Of the most common manga mistakes to watch out for and the most egregious is the dreaded Peanut Head Syndrome (PHS). PHS is the tendency many Western manga artists have towards exaggerating the curve between brow and cheekbone on their characters' heads, giving them a shape vaguely reminiscent of a peanut. Here's how Peanut Head happens – and how to fight it!

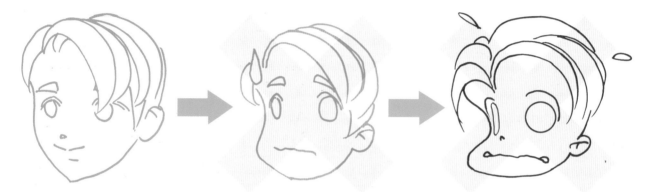

As you can see here, a well-drawn character has a simple curve joining the line of the cheek to the brow. Drawing this curve correctly produces a head with the basic shield shape characteristic of most manga styles. This shape is easy to draw when the artist has a good grasp of the actual anatomy of the skull.

Unfortunately, many new manga artists try to draw in a distorted, cartoon style before they know how anatomy works. As a result, the distortions produced in the shape of the face by the large, cliché manga eyes force them to try to compensate by grossly exaggerating the brow/cheek curve. Bye-bye shield shape – the Peanut Head is here!

Once you know real anatomy, you can distort shapes to no ill effect, but if you don't, your readers will pick up on it right away: your characters will simply look wrong. Here, PHS is taken to its ultimate; it's a caved-in mess that hardly looks human. Buckle down and study anatomy before you try cartooning. You can't break the rules until you know the rules!

Beware the temptation to substitute digital magic for drawing skill. Computers have their uses in making manga, but in the end it's your creativity the readers want to see, not flashy effects. Never use 'poser'-type programmes or other digital aids to disguise an inability to draw!

Four Other Common Mistakes

Fight Club

A good old-fashioned ESP-powered battle makes for great manga – once in a while. But despite the success of certain well-known manga/anime series based upon that theme, the fact is that a manga story consisting of one superhero showdown after another is boring. Avoid making your manga an endless parade of fight scenes.

Talking Heads

In like manner, a manga consisting mostly of a series of character head shots spouting speech is manga that is driven by words, not images – and thus is no manga at all. If you want to draw drama, great, but you have to vary your presentation – establishing shots, 'cartoony' drawing, action and dialogue are all part of the dramatic mix. As for dialogue, real-life interpersonal conversations very seldom sound like the ones many beginner manga artists write. No one (boy or girl) wants to waste time on a manga that reads like an 11-year-old girl's first diary. Always ask yourself, 'Are these words that I can realistically picture myself or someone else in the real world saying?' as you put your pages together.

Short and Stumpy

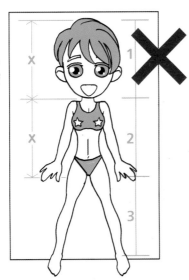

Because the face is the primary focus for information transfer, we all naturally tend to draw faces first, and the rest of the body as an afterthought. The result: weird, mutant-looking characters whose enormous, juglike heads are the same length as their torsos! Always check your proportions as you draw. And beware the Oompa-LooMpa look: drawing characters in real-life proportions (i.e. less than 7.5 heads high) tends to make characters look dumpy, stumpy and generally unattractive. Unless you're intentionally drawing a child, a dwarf, or a Hello Kitty-like cute character, always make sure your figures are at least seven heads tall.

The Tome/Magnum Opus

Resist the urge to draw that epic-length Regency romance or sci-fi trilogy right out of the gate. How many times have I seen talented would-be manga makers become discouraged and give up simply because they tried to do too much too soon! Don't try writing super-long stories at first; keep your early manga efforts short and punchy – 8 to 24 pages should be plenty while you're learning the craft. If you simply must make that manga version of *The Iliad* or *Gone With The Wind*, at least break it up into small chapter-sized chunks of 24 to 48 pages each. That way you won't be beaten by the thought of doing all 1,875 pages.

The Manuscript

And here you are – at the last stage of the production process, ready to produce the manuscript for your first manga. Great job so far!

If you followed the steps of the Process up until now, you should have a complete manga story in the form of a booklet of eight pages and four covers, folded size A5 (5.5in. x 8.5in). (If you couldn't help yourself and drew more than eight pages, that's okay; if you drew less, you may want to reconsider this whole manga idea.) Of course, the art you've produced so far is pretty sketchy and rough, but that's as it should be; up until now, you've been more engaged with creating the story than with producing polished art. Now, however, it's time to do just that.

Make sure your pages and covers are marked with their correct numbers (FC, IFC, 1, 2, 3, 4, 5, 6, 7, 8, IBC, BC for an eight-page booklet). Unfold your booklet until it's flat, take a craft knife or pair of scissors and carefully cut each sheet of your rough booklet apart along the fold, producing two A5 sheets (5.5in. x 8.5in). Each of the new sheets should have a complete page of art on both sides. Next, you need to enlarge your rough pencilled pages for finishing. To do this you'll need a supply of A3 (11in. x 17in.) paper and access to a photocopier. Load the paper in the machine, then copy each side of each of your new sheets at an enlargement of 200%. Since A5 (5.5in. x 8.5in.) is precisely half the size of an A3 (11in. x 17in) sheet, your blown-up pencils should fit the new paper exactly.

If all this is done as specified, you will end up with a stack of A3 (11in. x 17in.) sheets (one per page of your original booklet), each with an enlarged page of your rough pencils printed on it. You are now ready to produce the finished art that comprises the manuscript of your manga. Oh, and when you've finished enlarging them, tape the pages of your rough book back together in their original order – you'll need them later!

Each unfolded 8.5in. x 11in/A4 sheet produces two sheets (four pages of art) when cut along fold line.

It's lightbox time! Tape the enlarged roughs printed side down on to the glass, then tape a blank sheet of A3 (11in. x 17in.) over the top of it, matching the edges. When you turn the light on, the dark lines of the base drawing should be visible through the top sheet of paper. Your job now is to reproduce the images of the enlarged rough on the clean sheet, but instead of tracing the sketchy lines on the rough exactly, you redraw each panel using smooth, precise lines. In other words, you use the underlying roughs as a sort of skeleton upon which to 'hang' clean, finished line art. At this stage the basic work of drawing the book takes place: now is the time to fix bad perspective, bogus anatomy and suspect poses. You may need to trace the entire page, then tape the redrawn page on the lightbox and redraw the art yet again on another clean sheet in order to get the look you want. (Make sure you flip the base image over each time you redraw it on to a clean sheet so that any misdrawn areas become apparent.) As you draw the finished pencils, do not fill in solid black areas; mark them with a small X instead. Leave out word balloons, sound effects and so forth. These will be added in later. Do this for each of your pages in turn, and the manuscript is done.

And with that, you have now completed the major work involved in producing your own manga. From here on it's all polishing and preparing the book for print – which means no more pencilling! It's time for Embellishment, either mechanical (using real ink) or digital (using computer software). Let's be about it!

11 x 17"
Blank

11 x 17"
Rough

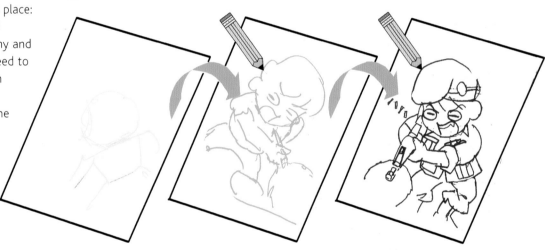

Using the lightbox, your original pencil rough...

...is flipped and redrawn using smooth, confident lines...

...and this flip/redraw process is repeated until the image is clean, correct and complete.

As we enter the final phase of the campaign, don't worry – when you reach out your hand and find an honest to goodness manga where a pile of wrinkled, smudged pages used to be, you'll know what to do.

Dismissed!

Manual Embellishment

Or, in other words, how to turn your pencilled manuscript into permanent line art. It's called putting ink on paper.

Pencilled art, no matter how 'tight' it is or how dark its lines may be, is not well suited to print reproduction. Embellishment is the process of transforming pencil art into line art suitable for printing (or scanning). In this section we'll cover the basics of manual embellishment (i.e. embellishment using pen and ink – also called 'inking'). It is a technique very similar to tracing, but – because ink leaves a different sort of mark to pencil – one that can be made to be so much more.

So here you are, your stack of tightly pencilled A3 (11in. x 17in.) manga pages waiting on the desk, ready to begin the embellishment process. Where do you start? Simple. First gather your tools. You'll need your lightbox, some pens and ink, markers, correction materials and, of course, a surface of some sort upon which to draw your finishes (completed pages of line art). Ready? Here we go.

First off, you're going to need something special to draw on. Plain paper won't do for inked lines – the ink will soak into the paper's fibres, causing the lines to spread out and look fuzzy (or 'bleed'). Furthermore, the rough ('toothy') texture of most papers will cause your nib to snag as it moves across the surface, making your inked lines look jagged and uneven. So, for

hand inking you are going to need something heavier, less absorbent, and smoother upon which to do your inking – a kind of smooth, stiff cardstock called board.

Which board to buy? It's up to you. Oh, you could spend a zillion bucks on that fancy art-store stuff, but, since we're doing this the B-Chan way (i.e. on the cheap), I recommend a far less expensive alternative: 4-ply white poster board, the kind they sell at the supermarket or stationer's in the school-supplies section. It usually comes in big sheets of about 22in. x 28in./55cm x 70cm – just cut it into

A3 (11in. x 17in.) sheets with a craft knife and steel straightedge – and you can buy enough to do a good-sized manga for not much more than the price of a decent burger. You ink it on the smooth side. If you prefer to spend more, you can, but poster board works fine, and you don't have to worry about the cost if you accidentally ruin a sheet or two.

You'll also need black, waterproof India ink (any brand is OK), your nibs of choice (see opposite for how to prepare them), a holder (you can saw the end off if it feels too long) and a couple of ceramic coffee mugs.

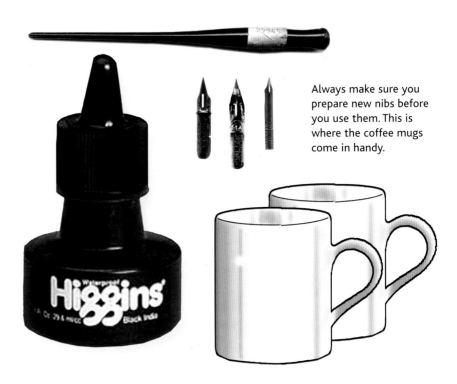

Always make sure you prepare new nibs before you use them. This is where the coffee mugs come in handy.

How to Prepare a Nib for Use

Metal nibs aren't suitable for use straight out of the box; you need to clean and smooth them before you start to draw.

Step 1
With a facial tissue, wipe the nib gently, taking care not to bend or break the delicate tip. This will absorb the manufacturer's protective layer of oil.

Step 2
The edges of a factory-fresh nib are covered with nicks, pits and metal burrs. To get rid of these, gently smooth the nib against the ring of unglazed ceramic on the bottom of a coffee mug, using a circular back-and-forth motion.

Step 3
Using a lighter or match, quickly heat the tip of the nib to soften the metal...

Step 4
...then cool the heated nib in a mug of cold water.

Step 5
Gently wipe the nib again with a clean tissue to remove soot and moisture. (Do not touch the nib with your fingers; the oils and moisture from your skin will prevent ink from clinging to the metal.)

Step 6
Using another clean tissue to hold the nib, firmly insert it into a holder, taking care not to bend the tip or leave fibres from the tissue clinging to it. The pen is now ready to use.

Inking is a craft unto itself, and there are many tricks you can use if you're an expert, but the basic process is uncomplicated: simply tape your pencilled manuscript page to the lightbox, tape a sheet of board on top of it, turn the lightbox on and trace the lines on to the board in ink using a pen. Fill in areas of solid black, remove the inked board or 'finish' and the manuscript page from lightbox and set the finish aside until the ink dries. Repeat until you have an inked finish for each page of the pencilled manuscript.

Once you have created inked finishes from each page of your manuscript, you're ready to move on to post-production. Taking care to file away your pencilled manuscript pages in case things go pear-shaped later, reduce each of your A3 (11in. x 17in.) finishes on to regular A4 (8.5in. x 11in.) paper on a photocopier and then file the finishes away for safekeeping as well. It's no shame to emulate the pros when it comes to inking your pages. Studying your favourite manga artist's ink technique is not the same as swiping his or her overall drawing style. Study as many different manga as you can and note carefully how the creator of each uses pen and ink to express dimension, mood, subject matter and other factors in his or her work.

Use a cheap artist's brush or a Sharpie®-type marker to apply large areas of black ink to the page. Ink the centre portions of the black areas first, then do the detail work around the edges with a fine-point marker to keep them sharp.

If you smudge or spill ink, don't panic – just wait for the ink to dry, then cover up your mistake using a correction pen. You can also use it to create sparkles, shines and highlights.

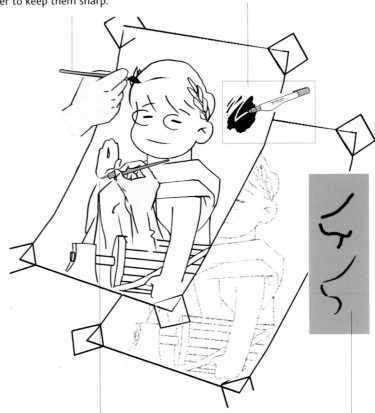

India ink takes a few minutes to dry, so it's important to take care not to smear the ink with your hand as you draw the page. If you are right-handed, start inking in the upper left corner of the page and proceed towards the lower right corner; lefties, begin in the upper left corner and ink towards the lower right.

The art of embellishment is more than just tracing, of course; it consists of creating line art that seems alive and dimensional to the viewer. The key to creating interesting inks is the living line — an expressive, smooth line that 'breathes' (i.e. varies in width). This is why markers are not suitable for embellishing — marker tips create a line that is the same width at all times (top). Such a line is 'dead' – visually flat and uninteresting. By contrast, the flexible metal tip of a drawing pen's nib creates a beautiful, flowing line (bottom) that varies in width and shape according to the pressure of the skilled artist's hand. Practice inking with a nib pen until you get the hang of producing a living line.

Digital Embellishment

Virtual inking – by computer. This is not really that different from manual embellishment, but you will need a scanner, computer and image-processing software, plus a digital tablet and stylus.

It all starts with your pencil manuscript: a high-quality pencil original is crucial for producing a high-quality digital file.

To digitally embellish your art, you have to create a digital facsimile of the pencil art, which means scanning it in. And unless you're wealthy enough to afford a tabloid – A3 (11in. x 17in.) – size scanner, you're going to have to do it with an ordinary, consumer-quality flatbed desktop scanner, which generally limits you to a scan size of A4 (8.5in. x 11in.) or smaller. Therefore, you're going to have to reduce your pencilled pages on a photocopier to produce scannable A4 (8.5in. x 11in.) art. Make sure you keep both your pencilled originals and the reduced photocopies on file in case you need them later.

During the early days of digital comics production (circa 1993), my business partners and I developed a method of 'digital inking' using PC hardware and software that substantially reduced per-page production time. Computers are a lot faster now than then, and image-processing software is better by orders of magnitude, but the basic process of embellishing pencil art using a computer remains the same: individual pages of pencilled line art are digitized at high resolution (>300 dpi) using a scanner (1), then saved as grayscale

TIFF files on a computer hard disk (2). Once saved, the artist uses a digital tablet and stylus (3) to clean up, correct and/or trace the pencil art. The end result is a print-ready black and white digital line art file, which is saved to the hard disk, ready for post-production.

Note: This section is an introduction to digital embellishment, not a complete text on the subject. As we review the techniques here, please keep in mind that this is merely an overview of the basic process; an entire book would be necessary to cover the topic of digital comics production in any kind of detail.

While I've tried to keep things as non-technical as possible, the instructions on the following page are based on the use of Adobe Photoshop raster image processing software. If you don't use Photoshop, it's likely the application you are using operates in a similar way; but you will need to adjust the instructions to match your software's terms and techniques.

Digital embellishment isn't really that different from manual embellishment – you're creating printable line art, but using virtual tools to do it. The first thing to do is to create a virtual lightbox so that you can trace the virtual pencils with your digital pen. Forget the mouse and the trackball; if you intend to digitally embellish your pages, a quality digital tablet and stylus are an absolute must. Tablets are a bit pricey, but as with all goods, you get what you pay for, so buy the best tablet/stylus combo you can afford.

Save each page of manga art as a separate file in a special folder called 'line art' or something similar. Make a backup copy and save it somewhere other than on your hard disk. Burning the folder and contents on to a CD-RW is a great way to make sure your project doesn't crash and burn – even if your hard disk does. Label your backup disks with the appropriate project name and page numbers, place in protective sleeves and store in a cool, dry, safe place.

Step 1
Scan in your pencil art and save as a grayscale TIFF file.

Step 2
Next, adjust the file's brightness and contrast (B = 20%, C = 45–100%) until the lines are crisp and black throughout. If the pencil original is drawn super tight and the linework is varied so the lines now appear to be 'inked', then you're done, but 99% of the time they won't be good enough.

Step 3
Save the file, then duplicate the layer the image is on and delete the original layer. This creates a two-layer file: a layer with the image on it floating on top of a white background base layer. Then dial the opacity of the image layer down to 20% or so, to get a virtual 'lightboxed' image that you can trace on a third, uppermost 'ink' layer. Save the whole schmear with layers intact – you're ready to do the actual inking.

Step 4
Use the stylus and tablet to trace the pencil image on to the top layer. Set the line colour to 100% black, and set the stylus to be pressure-sensitive so that you create a living line as you draw.

Step 5
Zoom in and redraw any geometric lines using your application's line-drawing tools. You may as well let the computer do what it does best – precision. Don't draw the panel borders, speech balloons, or sound effects in yet – we'll take care of those in post-production. When you have the line art layer completed, delete the lightbox image layer and flatten the whole works. Convert the file to bitmap format (this will eliminate most stray marks and fuzzy bits) and then back to grayscale. Check it over one more time for rough lines or unwanted marks, then save it as a grayscale TIFF file.

Borders

During post-production (or 'post') pages of art are composited (edited, augmented with additional materials), which includes procedures such as ballon and panel bordering, lettering, toning and FX.

Balloons

Balloons are areas of white space used to separate text from the graphic background. The standard text balloon has two parts: the bubble (containing text) and the pointer (tail to indicate the source of sound). There are no hard-and-fast rules for text balloons, but there are a few basic types that have become part of the visual language of comics. Their different shapes are used to characterize the source, tone or mood of the text they contain. Speech can also be indicated by drawing a doonesbury balloon – a simple line between the text and its source. In manga, the doonesbury is seldom used except for incidental text.

A The Western Oval

The standard balloon used for ordinary speech in European and American comics and cartoons. Usually 'free-floating' (not touching any of the panel borders), the Western Oval is not often seen in Japanese manga.

B The Tadpole Oval

The standard speech balloon found in most Japanese manga. Differs from the Western Oval in placement (usually in corners or along sides of panel) and in its tapering, tadpole-tail pointer.

C The Square (a.k.a. the Mad)

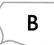

A rectangular balloon often used to depict mechanical 'speech' (e.g. when a robot is talking) or other sounds of non-human origin. A Square with its pointer like a cartoon lightning bolt indicates the sound produced by a radio or television set. Seldom used in manga; rarely used for ordinary speech in Western comics (except in Mad magazine, for example).

D The Vertical Balloon

A tall, thin, oval or polygon often used as a speech balloon in Japanese manga, especially to depict thoughts. Almost never used in Western comics due to its incompatibility with alphabetic writing, but is increasingly used in both idioms to contain an ellipsis (the '...' used to indicate a pregnant pause).

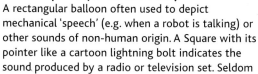

E The Western Burst

A jagged balloon used to indicate shouted or extremely dramatic speech. May be free-floating. Note regularity of points (drawn with short segments of line) and long, tapering pointer. Seldom found in Japanese comics.

F The Manga Burst

A burst drawn in a loose, calligraphic style. Commonly used in Japanese manga to indicate shouted or extremely dramatic speech or thought. May be free-floating. Note irregularity of points (drawn with short, expressive curves).

G The Classic Thought Balloon

A cloud-like balloon used in Western comics to show thoughts, dreams, or other non-verbalized communication. May contain images or words. Notable in its use of a train of increasingly smaller ovals in place of a pointer.

H The Manga Thought Balloon

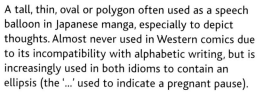

Used for the same purposes as the Classic Thought Balloon, the Japanese version takes the form of an irregular polygon, a painted burst, or a long oval. The Manga Thought Balloom has no pointer – the source is indicated by context and/or placement in panel.

I The Puff

Used for spoken sound effects (e.g. 'bang-bang', 'boo'), explosive/percussive sounds and breath noises (e.g. sighs, snorting), and speech/thought outside of or incidental to the main narrative. Note its short, squared-off pointer and chamingly crude shape. Often used in humorous contexts, the Puff Balloon is increasingly found in both Japanese and Western comics.

J The Scroll

Reminiscent of the speech balloons used in the earliest cartoons and comics. The pointer and bubble are drawn as a single, tapered shape; the text inside follows its curve. The Scroll is seldom used these days except for nostalgic effect.

Panel borders

Panel borders and balloons are drawn separately: the panel borders go on the embellished finish itself, while it's best to do your word balloons on a separate overlay sheet of paper. By putting the word balloons on a separate sheet you avoid having to cover up your actual art using white paint or correction fluid, neither of which is much fun to do lettering on. Once the balloons are done, you then cut them out of the overlay and paste them on to the art. This sort of cut-and-paste page assembly is called mechanical layout, and pages produced in this fashion are called mechanicals. (The craft of drawing precise lines and shapes using physical tools is called mechanical drafting.) Believe it or not, all books, magazines and newspapers were once created and laid out mechanically; before computers and laser printers were invented, there just weren't many other ways to generate art and layouts for printing other than drafting and paste-up. Fortunately for you, I, the venerable and inscrutable B-chan, was working in the business during those primitive times, and on the following page I have recorded the arcane process of creating mechanicals in step-by-step fashion for your use. Manual post-production is time-consuming and tricky compared to digital post, but it works. Lotsa luck!

Mechanical drafting/paste-up tools and materials

You'll need the following items to do your paste-ups:

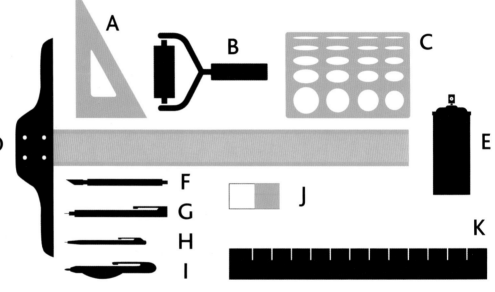

A Triangle
A transparent 30°-60°-90° plastic triangle is best. Get the biggest one you can find. Tape pennies or squares of thin foam-core board to one side so that the triangle sits above the surface of your drawing board to prevent 'bleeding'.

B Brayer
A rubber roller mounted on a handle. Used to press down glued-on items firmly.

C Ellipse template
Get a variety in thin transparent plastic with different sizes and angles of ellipses and circles.

D T-square
Used for drawing horizontal or vertical lines (ruling). Get one with metal or bevelled transparent edges

E Aerosol adhesive
Spray glue is the best stuff for sticking paper to paper. It can be hazardous to the health of humans and animals and may damage furniture and clothing. Only use in a well-ventilated area.

F Craft knife/razor knife/scalpel
These consist of a pen-like barrel tipped with a replaceable (and extremely sharp) steel blade. Useful for cutting out complex shapes. Exercise extreme caution when using these knives: the blade can cause severe injury if used carelessly. Younger artists should always get the permission and/or assistance of a responsible adult.

G Technical pen ('tech pen')
A drafting pen used to draw lines of precise width. These can be expensive and hard to use; get the disposable kind if you can. A tech pen with .125in. diameter point is ideal for drawing panel borders.

H Mechanical pencil.
Any kind is OK.

I Correction pen
The one you're using for your embellishments is fine.

J Eraser
Get the plastic kind that won't abrade your inked lines.

K Straightedge ruler
A good long one with a cork strip on the bottom is best.

Paste-Up The Old-Fashioned Way

Here's how to do post the low-tech way – by hand.

Step 1
Tape your inked finish to your lightbox. Use the ruler, T-square and triangle to make sure the top and sides of the finish are parallel with the edges of the lightbox.

Step 2
Draw the panel borders directly on to the finish using the tech pen, triangle and T-square. When the ink is dry, erase the pencilled rough borders from underneath; use a correction pen to fix any mistakes then leave to dry.

Step 3
Using the drafting tape, attach an overlay sheet to the lightbox precisely over the finish. Use a pencil to write the dialogue and any other text on the overlay sheet.

Step 4
Using the pencil, sketch in the outlines of the balloons around the pencilled text on the overlay. Then carefully go over these outlines on overlay using the tech pen, ellipse template, and

straightedge. After the ink dries, carefully letter the text inside the balloons with the tech pen or nib using your pencilled text as a guide. (If the text is typeset, cut it out with the craft knife and attach it to the appropriate balloon using aerosol adhesive and the brayer. (See page 100 for more information on lettering.) When the ink is dry, erase the sketch lines.

Step 5
Detach the overlay sheet. Place it on the self-healing cutting surface of the glass lightbox top. With the craft knife, carefully cut out the balloons and set them aside.

Step 6
Spray the reverse side of the balloons with aerosol adhesive and carefully place them on the finish. Use the brayer to press them flat, taking special care that no wrinkles or unstuck edges are left. Attach a blank sheet of overlay paper to the top edge of your finish with tape to protect the art beneath.

Digital Post-Production

The task of post-production is much easier when a computer is used to automate the process. As with Digital Embellishment, this overview is based on the use of Adobe© Photoshop©.

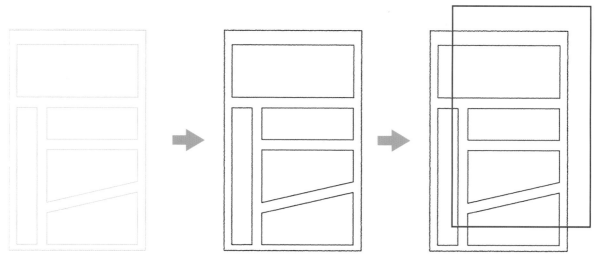

Step 1
If you used manual rather than digital embellishment, scan in your A4 photocopied finish page (>300 dpi, grayscale TIFF). Create a folder on your hard disk named Line Art and save file.

Step 2
Adjust brightness/contrast until the linework is crisp and clear. Change the file to bitmap mode at the same resolution, then back to grayscale, and save again.

Step 3
Create a new layer on top of the background layer and name it 'panel borders'. Save.

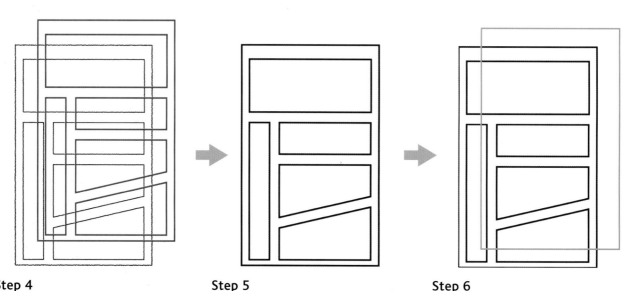

Step 4
Using the pencil tool, draw 100% black borderlines on the 'panel borders' layer to match those sketched in on the background layer. Make lines 5–10 points in width. Use the eraser tool to square off corners neatly. Save.

Step 5
Use the eraser tool to remove sketched-in borderlines from background layer. Set 'panel borders' layer to 'darken' mode, then flatten image. Save.

Step 6
Use the pencil tool in black to fill in gaps between the line art and the borderlines; use the pencil tool in white to cover up lines that extend past the borderlines. Save.

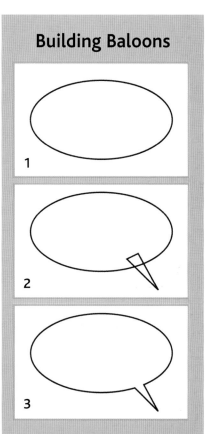

Building Baloons

Step 7
Create a new layer on top of the background layer and name it 'balloons'. Save.

Step 8
Using pencil, lasso, marquee, and ellipse tools as needed, draw 100% black borderlines on the 'balloons' layer to match those sketched in on the background layer. Make lines approximately 1–3 points in width. Use eraser and pencil tools to square/sharpen corners, points, and pointers. Fill each balloon with opaque white. Save.

Step 9
Using the type tool, create type layers and input (or import) text for balloons (right). Using the move and marquee tools, cut type into blocks and centre them in the appropriate balloons. Hide background layer and merge balloon and type layers. Save.

Step 10
After saving image, save a copy to a backup disk (e.g. a CD-RW) and another to your Line Art folder.

I prefer to build my balloons (and set my type) in Adobe Illustrator©, an EPS-based vector graphics application (as opposed to a raster graphics-based application like Photoshop©). It's easier and more precise to make type and balloons using vector graphics and then to import them into your post-production Photoshop© docs. Should you follow my lead, build the balloons using the three-step method described, then import a low-res copy of the line art and position them using it as a guide. Finally, dump the low-res line art, save, and open the Illustrator© EPS file in Photoshop©. The balloons should rasterize automatically upon import; just check the positioning, flatten the file and you're done!

More About Lettering

Manga is primarily a visual medium – but text plays an important role. If you want your manga to have maximum impact, it's essential that you know how to communicate effectively using text.

Two methods of lettering exist in manga: calligraphy (lettering by hand) and typesetting (lettering using a machine – almost always a computer). Japanese manga differ from Western comics in that the former tend to be lettered using typesetting (samurai manga artist Hiroshi Hirata is a notable exception), while the latter tend to be hand-lettered. It is possible to combine the two forms by typesetting on a computer using a typeface (a complete 'alphabet' or set of letters, numerals and other marks) with letterforms that appear to be made by hand. Such handwriting fonts (a font is the digital version of a typeface) are widely available; it is even possible to make a custom font from your own handwriting!

For those who prefer calligraphy, it's vital that you learn how to write the letters of the alphabet clearly and consistently. Comics lettering is small, so your lettering should be simple and readable. Bold, open capital letters fit the bill. Such letters, called block capitals, are the key to creating readable comics text by hand. The block capitals that I use are shown at the top of this page. (I use the lower-case lettering for occasional 'special effects' text (e.g. a character's subconscious thoughts or mutterings) I learned how to write this way in the US Navy; at sea, where miscommunication could result in disaster, there's no room for sloppy handwriting!

On the right are four basic steps to doing neat, readable hand-lettering:

ABCDEFGHIJKL
MNOPQRSTUVW
XYZ1234567890

abcdéfghijklmñô
pqrstüvwxyz.,;:
" " " " « » ! ? # @

WHO WOULD
FARDELS BEAR

WHO WOULD
FARDELS BEAR

Step 1
Rule some guidelines in pencil on your lettering overlay sheet. Sketch in your text, adjusting the spacing between words and letters as necessary.

Step 2
Ink in the letters using a tech pen or nib. Make sure you use drafting ink or waterproof black India ink — marker ink isn't permanent and will fade and erase.

WHO WOULD
FARDELS BEAR

WHO WOULD
FARDELS BEAR

Step 3
In pencil, sketch in the appropriate balloon shape. Make sure that your text block is centred in the balloon with a comfortable buffer of white space between the borders and the text block.

Step 4
Draw in the balloon borders in ink. Gently erase the pencil marks with the kneaded rubber. Cut out and paste the balloons on to the page when the lettering for each page is complete.

Digital lettering

Lettering is much faster and easier on the computer; you can rearrange words, make changes on the fly and fix mistakes instantly when you do it the digital way. However, you need to be careful that your digital lettering is clear and easy to read. The most important way to do this is to be judicious about which fonts you use for lettering: simple, clear fonts are much easier on your readers' eyes than are complex, 'artistic' fonts.

Fonts come in two basic styles: serif fonts (fonts with serifs – little lines – at the ends of each stroke) and sans-serif fonts (those without). Either type is okay for comics lettering, but keep text short and to the point: big blocks of text are boring and hard to read no matter what font you use. Above, the first two balloons show examples of good font choices (Frutiger then Times) and the second two show poor choices (Odyssey then Banana). Make your font size big enough so that the reader can make it out at arm's length without having

to squint, and be sure you adjust the leading (pronounced 'led-ing') and kerning of your type so that the letterforms are as clear, as compact and as legible as possible.

The art of FX

FX (or 'effects') is lettering intended to create the impression of sound or atmosphere in the mind of the reader. Manga creators have developed FX to a high art over the years, creating text to represent such subtle sounds as melting cream (surin), squeaking springs (giitchi giitchi) and excitement (doki doki). Couple this with straight onomatopoeia (the vom vom vom of machine-gun fire, the nya of a mewing cat, or the kisshaa of

heavy rain) and you get a manga storytelling tool of considerable power. Western comics are also famous for the use of sound effects, but these tend to be much more caricatured and 'cartoony' than those commonly used in manga. Of course, some manga artists choose not to use FX at all (I myself rarely use them), but the vast majority of manga have them. My advice is to read a wide variety of manga and comics and

note how the various authors and/or artists use FX, then make up your own mind how you want to do so in your works. If you do choose to use FX, do the lettering on a separate overlay sheet or digital layer from your base art, then paste it up or composite it once you've got things the way you want them.

Toning

You've got your black line manga artwork. But now you need to give it some depth and contrast. Here's how you create tonal effects by hand.

Unlike colourful Western comics, Japanese comics have historically been printed in black and white; as a result, manga creators have developed a dazzling repertoire of techniques for embellishing black-and-white art to give the viewer the impression of tonal qualities between black and white without the use of colour printing. We call these tone effects, and the techniques for creating them toning. Toning is usually accomplished through the use of screentones ('screens') – paper-thin sheets of adhesive-backed transparent plastic with black ink printed in patterns upon them and mounted on a backing sheet. The 'screening' effect of these patterned areas upon the line art creates the impression of grey areas on the page when it is viewed, giving impact, depth and dimension to black-and-white line art.

While other toning methods exist, screens are by far the most common method used in Japan. The basic method of using tone consists of:

Step 1
Lay a sheet of screentone (with backing sheet still attached) over the page to be toned and fix in position while you work with drafting tape.

Step 2
Using a small, disposable craft knife (the type with the break-off, segmented blade), carefully cut out the outlines of the areas you wish to tone from the screentone. Cut only the adhesive-backed plastic layer of the screentone, not the backing layer or the page beneath. (Be sure to make your cut-outs slightly larger than the areas you want to tone.) Remove the cut screentone from the backing sheet and lay it on the page at the desired location.

Step 3
With the craft knife, carefully cut away the 'flash' (extraneous screentone around the area you wish to tone) as well as any 'holes' (areas that should be left white) from the screentone. Finally, gently rub down the tone using a burnisher, tone scrubber, or your finger (covered with facial tissue) to press out any air bubbles or wrinkles and to ensure that the screentone stays put.

Screentone comes in various percentages, or shades, of grey. The higher the percentage value, the denser its screen pattern is and therefore the darker its perceived shade of grey will be to the viewer.

A wide variety of screentones exist: patterns, bursts, even clouds and flowers. But there's more to toning than just cutting it out and sticking it down! Toning is an art form all its own; a superior craftsman can also scrape, cut and erase screentone to produce a nearly limitless variety of shading and texture effects. This craft is called etching the tone, and it's well worth learning; my suggestion is to gather together good samples of etched art created by the best tone artists (Tomoko Saito immediately comes to mind; her tone work is of superior quality and is widely available in North America and Europe) and study the techniques they employ.

The basic process for toning

Step 1
Lay tone over art.

Step 2
Using the tip of the craft knife's blade, cut out the desired area, then affix tone to art. Trim away flash and holes.

Step 3
Using the edge of the blade, etch away tone from the highlight areas. The tip of the blade may be used to etch away narrow lines of tone or to create crosshatch effects. Soft-edge bokashi ('blur') effects can be created by abrading the tone with a special tone eraser (a sand eraser) or a small piece of fine grit sandpaper.

Step 4
Lay down next tone layer. Repeat the process for each area as necessary.

Digital Toning

Screentoning the traditional way is expensive and learning to use it without ruining your original art can be tricky and frustrating. Luckily there is another method.

As screentone costs quite a bit, can be difficult to find, and the technique takes a while to master, I have developed a method on the computer that will duplicate the effects of mechanical toning without the expense, the hassle and the risk. I call it 'digital toning'.

To understand digital toning, let's take a look at how toning actually works. When a ray of multicoloured ('white') light hits the surface of your manga page, the paper fibres reflect almost all of it away; this reflected ray hits the light-sensitive area of your eye (the retina) and an image of white

paper is created in your mind in response. In other words, an area that reflects all of the light hitting it is perceived to be white. On the other hand, dark-coloured areas of the paper absorb the incoming light ray, reflecting nothing on to your retina; thus, such areas appear black. From this we can see that a piece of black-and-white art contains only black areas and white areas, and nothing else.

When screentone is applied to the page, areas of grey are created – or are they? Surprisingly, the answer is no! A sheet of tone contains no 'grey ink' – there is no such thing! The 'grey' appearance created by screentone is an illusion, achieved by a regular pattern of opaque dots of black ink overlaying the white paper behind it. Such a pattern of black dots is called a halftone pattern. The closer together (denser) these black dots are, the more reflected light they absorb, and the darker the area they cover appears to be. For example, a screen of 50% halftone will block 50% of the white light reflected from a page towards your eye, creating the impression in your mind of an area that is only one-half as bright (white) as the paper around it; a

Physical Sheet of Tone

Digital Sheet of Tone

Physical Document

Digital Document

screen of 100% halftone will block 100% of the white light reflected from a page towards your eye, creating the impression in your mind of an area that is black compared to the paper around it. This impression of lessened brightness between white and black is what we call grey.

Halftone screens are how grey tones are produced in black-and-white media. A printing press only prints solid areas of ink, but by breaking these areas up into tiny dots that partially block reflected light from the page, the illusion of grey is created in the mind of the viewer. (Take a magnifying glass to a newspaper and check it out for yourself!) Likewise, by placing a sheet of printed black dots (screentone) over a sheet of white paper, we can create the illusion of grey tones on the manga page.

And that holds true for the digital manga page as well. When working in a digital image programme, placing a layer containing a regular pattern of black dots over a layer of digital black-and-white art creates exactly the same visual 'grey' effect as does putting printed screentone over real, physical art. And making patterns of dots is something computers do well! With this in mind, it's easy to see how it's possible to create 'sheets' of virtual screentone in an image programme and layer them on top of our manga pages just like we do with printed screentone in the Real World. Here's how you do it:

How to create sheets of virtual screentone

Step 1
Open a new document in your image programme (Photoshop©, etc.). The document should be grayscale and of the same dimensions and resolution (dpi) as the image you wish to tone.

Step 2
Select the entire area of the document, then Fill with the desired percentage of black. (For example: if you want to create a 25% grey screen, make your fill colour 25% black.)

Step 3
Convert the document to Bitmap Mode (Halftone Screen; 35 to 85 lines per inch; Angle = 45°; Shape = Round). A halftone pattern will appear. Convert back to Grayscale Mode (Size Ratio = 1). Save document in TIFF mode as '25%gray.tif'.

Step 4
Open the document containing the art you wish to tone (the 'target' doc) and create a new layer (Multiply Mode) named Tone. Then, using the Rubber Stamp tool, sample the halftone pattern from '25%gray.tif' and 'paint' the halftone pattern on to the Tone layer of the target doc as desired.

Step 5
When finished, use the Eraser tool to erase unwanted tone, and the Pen, Paintbrush and Airbrush tools to 'etch' the Tone layer the way you want. Flatten the Tone layer on to your base art and save. And the good news is there's an Undo button if you mess up!

Hatching

Hatching builds up the appearance of tone or shade. The more lines you use in a particular area, the deeper the tone will be.

Hatching is the art of toning a drawing using pen and ink. Just as with screentone, the purpose of hatching is to screen out part of the light reflected from selected areas of your drawing, thus giving those areas a grey appearance. Unlike mechanically produced screentone, however, the 'screen' in the case of hatching is produced by your own little fingers. The uneven and irregular quality of hand-drawn pen-and-ink marks can give a drawing an air of nostalgia, drama, wistfulness or many other romantic and/or dramatic emotions. Hatching can also be combined with screentone to give your manga a sophisticated chiaroscuro look. On these pages we'll discuss the basic process of hatching and other pen-tone effects.

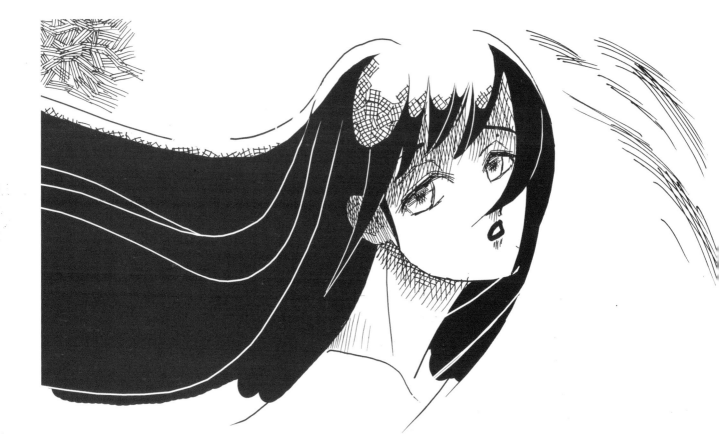

You should never do this in your manga, but for the purpose of example I've toned this drawing using all the major methods of hatching at once. Be careful: a drawing with too much hatching or other detail is unattractive and confusing. (The technical term for such drawings is 'overworked'.)

Freehand hatching patterns

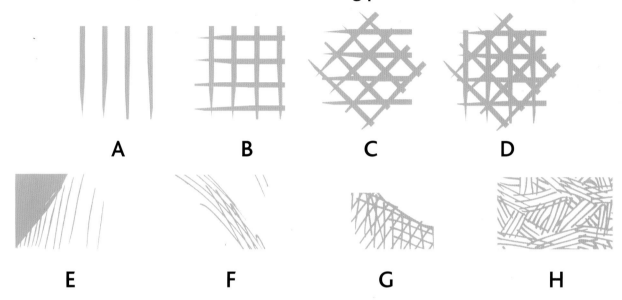

A B C D

E F G H

Know the four basic freehand hatching patterns:
A singlehatching
B crosshatching
C triple-hatching
D quadhatching

Other methods of hatching include:
E shading
F ropehatching
G offset hatching
H basketweave

When hatching, use a Crowquill nib, technical pen or fine-point marker.

Other useful patterns

Here are three additional hatching patterns that suggest movement. Draw them with a marker or nib pen using a bevelled straightedge. Make sure you taper the width of each line as you draw: to do this, gradually decrease the pressure of the pen against the paper as you rule the line. These effects are actually much easier to create using a computer and image software, and you have an Undo button to fall back on.

Speedlines.
These are tapered, parallel lines or curves used to indicate movement, emotion, action, or (of course) speed.

Zooms.
These are made by drawing speedlines in towards a common centre.

Bursts.
A burst is drawn like a zoom, only you overlap the speedlines instead of leaving them separate.

Colour

Manga is inherently a black and white medium – but colour has its occasional uses. Here are some tips for toning in colour.

The first thing to remember is that manga is a form of writing, and as such works best when done in black and white. If you're telling your story right, you don't need colour. However, it's not unusual for serial manga in Japan to have a few colour pages at the beginning of each chapter, and you may choose to do the same. (Keep in mind that any use of colour will multiply the cost of printing two to four times!) You could take up a whole book covering the topic completely; I have a couple of pages here, so I'll do my best to give you a general overview of it.

Manual colour

In Japanese manga, colour is usually applied by brush using coloured ink or watercolour – both of which require skill to do well. Another method is coloured screentone, which can be cut out and applied to black-and-white art in the same manner as grey tone. This method is useful for producing print-ready art using the old photographic printing methods. However, if you plan to scan and/or colour copy your art, there's no reason you can't use any medium you like to colour your comics, such as coloured pencils, pastels, design markers, even crayons.

One caveat: don't colour directly on to your original artwork! Photocopy the line art on to an appropriate medium (posterboard, drawing board, etc.), and do the colour on that surface. That way if you don't get it right first time, you haven't ruined your original work.

Digital Compositing.

When you have everything the way you want it, duplicate the Line Art layer, drag the duplicate to the top of the stack, set mode to Multiply, then flatten the whole sandwich into a single layer and save in CMYK Color Mode. (Make sure you save the coloured art separately from the black-and-white originals.) The deed is done!

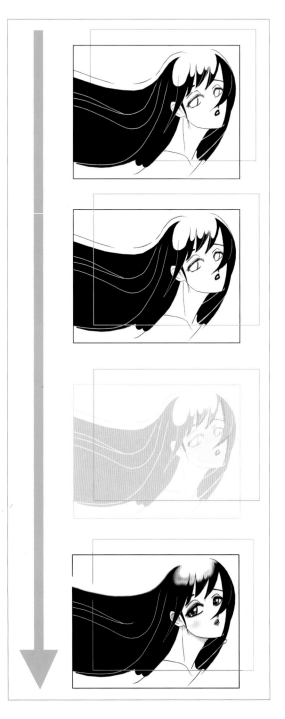

Highlight Layer — Normal

Second Line Layer — Multiply

Colour Layer — Multiply

Line Layer (background) — Normal

Sandwich

Digital colour

Back in the 1990s, my partners and I developed a relatively quick, simple and effective technique for applying colour to manga art using the computer. We called the process Go!Color, and it works very well for those using applications such as Photoshop®. The basic Go!Color process is described below.

Input and Prep

1. If your line art is not already in digital form, scan it at 600 dpi and save it as a grayscale TIFF image.

2. Convert Mode to Bitmap (50% threshold), then back to Grayscale. Save.

3. Duplicate Background Layer containing line art; name new layer 'Line Art'.

4. Delete art on Background Layer; fill with white. Save.

5. Switch Mode to RGB Color. Create new layer above Line Art layer; name new layer 'Colour' and set to Multiply Mode. Save. Using the Selection Tool (Tolerance ±24), click inside the area you wish to colour in the Line Art layer. (If the Tool selects areas outside the area you wish to colour, click off Selection, then use the Pencil tool to close any gaps in line art between the desired area and other areas.) When the area is selected, go to Modify menu and Expand the chosen area by 2 pixels.

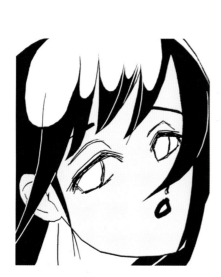

Colouring

1. Switch to Colour layer.

2. Use Color Picker or Swatches Palette to choose the desired colour; then, using the Paint Bucket tool, fill the area with colour. Save.

3. Repeat the process until all desired areas are filled with colour. Save.

4. Once complete, you should have a 'sandwich' of layers, with the Colour layer on top, the Line Art layer in the middle, and the white Background layer on the bottom. You may now wish to thicken the sandwich by adding extra layers for highlights, colour holds (areas of colour not bounded by lines), gradients or other effects.

Preparing To Print

Before you go to press, spend a little time assembling all the materials for your book. Trust me, you'll be glad you did.

$$p / 4 = s$$

p = number of pages of original art

s = number of pages of original art

The dummy book
One of the most important things you can do to make the printing process easier is to make a dummy book – a sort of scale model of your book. The dummy book helps you keep the physical structure of your manga book straight, both in terms of how many sheets of paper you'll need and how the book's layout will work.

Building the dummy

Step 1
Using the formula (above right) determine how many sheets of A4 paper you will need to print your book.

Step 2
Fold each sheet in half to form a signature of four A5 pages.

Step 3
Stack all signatures to form the guts (interior pages) of the book. In pencil, number the pages consecutively.

Step 4
Fold another sheet into a cover signature to represent the four covers of the book.
Step 5
Label the cover signature.

Step 6
Stack the guts with the cover signature on top.

Step 7
Staple together.

Reducing and trimming
It's time to make your pages of original art camera-ready; that is, ready to be printed. If you built your pages mechanically (i.e. on boards), you'll need to individually photocopy each page, reducing its size to fit a A5 (5.5in. x 8.5in.) sheet. If you built your pages digitally, simply print them out at the appropriate reduction (the correct reduction factor for creating A5 (5.5in. x 8.5in.) copies from A3 (11in. x 17in.) originals is, of course, 50%). Take care that the art on each page of your reduced-size copies is centred on its A5 (5.5in. x 8.5in.) sheet, trimming away any excess paper around the edges with a craft knife. A border of white space ¼in. (50mm) or larger should be left around the art on each page as appropriate.

Once all your pages are reduced and trimmed as necessary, set your hand-drawn originals aside in a safe place, then stack the pages back to back in consecutive order and take them to the print shop with the dummy book.

If all this seems complicated, don't worry – it's pretty common sense stuff once you get the hang of it. And don't worry about messing up – as long as your original art is safe, you can use the trial-and-error method without fear until you get things right. Most importantly, don't be shy: ask the copy shop staff or an experienced self-publisher to walk you through things if you have trouble at any stage of the printing process.

Photocopying

Also known as xerography, this method of printing represents a good choice for the beginner manga publisher. Here's how it works.

Photocopying is an electro-photographic duplicating technique developed in 1938 by Chester F Carlson. It works by the xerographic process – a system of 'dry' (inkless) printing in which light and electricity are used to capture an image photographically on to a rotating drum and then to a sheet of paper where it is reproduced using a carbon powder (toner) and iron particles (fuser) instead of ink. There are many different brands of copier, but all of them work according to the basic Carlson xerographic principle.

Photocopying is something you will likely be familiar with. This makes it the ideal choice for first-time manga publishers. Why? Three reasons:

1. Ease of use: almost everyone has run a few copies off at some point in their lives – making the learning curve for operating the machine very shallow.

2. Low cost: self-service copies on standard paper rarely cost more than a couple of pence/cents per page to print, making even the biggest books affordable for the average manga circle.

3. Convenience. Photocopying services are ubiquitous, some are even open 24 hours a day! Self-publishers smile knowingly at the thought of the pre-convention all-nighter, where members of the group spend all night at the local copy shop working hard to get

the Book printed in time for sale! The downside to photocopying is its quality. Copy machines are photographic, and as such are prey to the usual camera-type problems: scratched, dirty and defocused lenses, poor illumination, poor contrast control, blotchy solids and low fidelity (blurriness). Keep this in mind when making your choice of print method. If you choose to print your books using copiers, pick the highest-quality machines you can find, which will usually be found at the higher-end retail print shops or at commercial service bureau printers, which generally don't allow self-service copying (and therefore charge more per print).

The Xerographic Process works as follows

Step 1
The rotating drum inside the copier is first charged with electricity.

Step 2
A bright light is reflected from the source image sheet on to the drum. Where light hits the drum, its surface (a semiconductive material) is electrically neutralized. The pattern of charged and neutral areas on the drum produces a reverse (mirror) image of the source image.

Step 3
As the drum rotates, charged areas attract particles of carbon/iron toner from the reservoir, producing a positive copy of the source image on to a blank sheet of paper drawn between them. The drum is then electrically neutralized

Step 4
The sheet with the toner image passes between heated rollers, which fuse the toner into its fibres, producing permanent black lines duplicating those of the source image.

Printing on a photocopier

The low-tech method of printing and collating your books – simple and inexpensive; but if you're planning on printing a sizeable number of copies, bear in mind this is pretty time-consuming.

Compiling

Most copiers these days are pretty user-friendly; if the ones you are using are not, or if you get confused, ask a print shop employee for help. Just show them your dummy book and your originals and explain what you're trying to do. Odds are they'll be eager to show you the ropes.

Compiling is the process of copying your original art (four pages at a time) on to single two-sided sheets in the correct order for making a booklet.

To start out you'll need to know which pages will be printed on which sheets. And that's where the dummy book comes in handy.

Collating

It's time for the final step of the production process: collating – building the individual copies of your book from the copied pages – and it's best done as a group activity. One fun way to do it is to have a collating party.

Gather everyone in your manga circle at a central location (the usual place will be fine), organize some food and drink and lay out the sheets in stacks on the table in numerical order: first the cover stack, then a stack of Sheet 1, then Sheet 2, etc., each stack with the A side facing up. Once this is done, form a line, then have each member go down the line, picking up the top sheet of each stack and placing it on top of the previous sheet: cover sheet on the bottom, Sheet 1 on top of that, Sheet 2 on top of that, all the way down the line until a complete book is collated.

Then get each member to staple through their completed stack using a heavy-duty stapler (see pages 116–117) and fold the whole thing over.

And there it is: the finished book, photocopy style. Stack the finished books in a box and you're ready to sell 'em, lend 'em, or give 'em away.

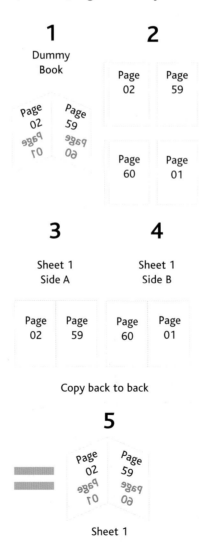

1
Dummy Book

Page 02 Page 59
Page 01 Page 60

2

| Page 02 | Page 59 |
| Page 60 | Page 01 |

3
Sheet 1 Side A

| Page 02 | Page 59 |

4
Sheet 1 Side B

| Page 60 | Page 01 |

Copy back to back

5

Page 02 Page 59
Page 01 Page 60

Sheet 1

Using the dummy

Step 1
Determine which four pages of art will go on each sheet.

Step 2
Copy two pages side-by-side on to the front of a sheet, then the other two on to its back. (Don't put your original art away just yet.)

Step 3
You now have an A4 (8.5in. x 11in.) sheet with two pages copied on each side. Check to make sure that none are laid out upside down with respect to the others!

Step 4
Check the pages on the sheet against the dummy book to make sure you got them in the right order and on the correct side. (The side of the sheet that faces the centrefold of the book is the A Side of the sheet; the side facing the cover is the B Side.)

Step 5
Fold each sheet carefully along its centreline (towards the A side), press it flat, and store. Once you have all of your art copied on to sheets, then make multiple copies of each sheet as required by your print run (i.e. if you plan on printing 100 books, you'll need 100 copies of each sheet). As you complete the copies of each sheet, stack the sheets neatly and in order and keep them from becoming jumbled together. While all of this is going on, ask the print shop employees to copy your covers in colour on to cardstock (#60 or heavier).

Digital Printing

New methods of digital image processing and duplication can produce printed pages of exceptional quality both quickly and cheaply.

Over the past few years an exciting new way of creating printed images has become widely available. It's called digital printing (DP), and in terms of speed, quality and convenience it blows photocopying into the weeds. Yes, it's a bit more expensive, and no, you can't do it yourself (the machines are complex and require training to operate well), but the combination of digital scanning, laser imaging and sophisticated xerography used by digital printers can create prints that are all but indistinguishable from high-price offset litho images. In my opinion, DP is the best, most cost-effective method of self-publishing available to the amateur today.

Each DP machine is a fully electronic publishing system. You can either feed in hard copy originals or copy PostScript® digital page files directly into the unit's memory. And no expensive printing plates are required – these machines create their images using the same process used in high-quality laser printers.

Best of all, these versatile machines are inline systems; that is, they can print the guts of the book on paper and the covers on cardstock, then auto-collate and bind the book (using any of several methods). And they do it all with tremendous speed – up to 180 copies per minute.

To print your book using DP, locate a printer that offers digital printing services, either a retail printer (a print shop catering to the general public, such as a copy shop) or a service bureau printer (a printing company that specializes in commercial accounts) and drop in. Bring along your dummy book and pages and explain to the sales representative and/or press technician what you're trying to accomplish, using the dummy book as an example. Odds are that the guys and gals in the pressroom will give your project their extra-special attention; after all, comics pages are a lot more interesting to print than the endless runs of insurance forms and estate agents' paperwork that make up the bulk of a typical printer's business! Once you're agreed on what the job entails, you then negotiate a fair price and agree payment terms. The professionals will handle the rest! When the first book (a.k.a. the proof) comes off the press, the sales rep will call you into the shop and go over it with you and a technician to make sure everything is the way you want it. This is called a press check, and it should be taken seriously: once you sign off (give the printer your go-ahead to print) on the book, you'll have to pay for it – mistakes and all!

For practical reasons, it's best that your comics circle delegates one person to handle all the details of the printing process – dealing with problems, handling the money, signing off on the proof, and so forth. This production manager should be someone familiar with the printing process, if at all possible.

Colour Printing

Although most of your manga will be black and white, there may come a time when you wish to include colour on more than just the cover. Here's some info about colour printing.

Light is that subset of the spectrum of electromagnetic radiation which is perceptible to the human observer. The light we see comes either directly from a light source (direct illumination) or by reflection (reflected illumination). For example, we call light waves with a frequency of 780–622 nanometers and a wavelength of 384–482 terahertz 'red light'. The human eye contains light-sensitive cones that are sensitive to three specific frequencies of light: the frequencies we call red (R), green (G) and blue (B) light. When the eye is directly illuminated by light in these frequencies, the brain perceives the combination as being colourless 'white' light.

What is colour

Colour is a mental perception created by different frequencies and wavelengths of reflected light – a happy combination of light, object and observer. When the direct white light of the sun or another light source bounces from an object's surface into our eyes, we naturally perceive that object as being white in colour. However, most objects do not reflect all frequencies of light equally – they reflect or absorb various frequencies of light according to their atomic makeup. This is what gives an object its perceived colour –

the relative proportions of frequencies of light absorbed and reflected by a given object.

Printing colour

When ink is applied to the surface of a white sheet of paper, the atomic structure of the paper is altered, and so are the wavelengths our eyes perceive when looking at it. White light reflects from the paper's surface through the ink layers, each of which absorbs certain colours while allowing others to pass through to the eye. Over the years, it has been discovered that by combining cyan (C) (a kind of blue), magenta (M) and yellow (Y) transparent inks, plus black (K) on a white surface in various proportions the impression of almost any colour can be created in the mind of the observer. When no ink is present, all colours bounce into the eye, and we see white paper. Cyan ink absorbs all the red light passing through it; yellow ink absorbs blue light; and magenta ink absorbs green light. When C, M, Y and K inks are all present, all the light is absorbed, and we see black. Since each colour of the CMYK set subtracts from the amount and type of reflected light reaching the eye, CMYK colour is known as subtractive colour.

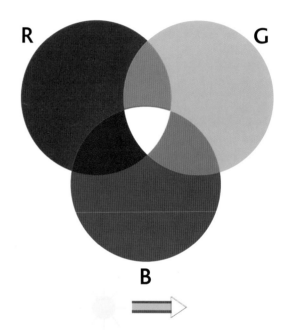

Additive colour: R + G + B = White

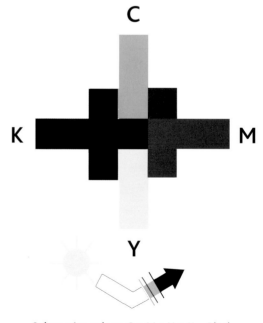

Subtractive colour: C + M + Y + K = Black

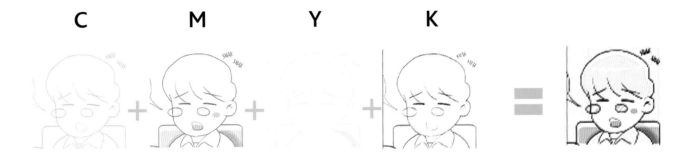

C + M + Y + K =

Colour lithography

The most widely used method of colour printing is called offset lithography. To print a colour lithograph, the original art is photographically or digitally colour-separated into at least four single-colour (monotone) images, called channels – generally, the Cyan (C), Magenta (M), Yellow (Y) and Black (K) channels. By superimposing printed images of these four colour channels, it is possible to reproduce the colours found in the original art with a high degree of fidelity.

Offset lithographs are printed using an offset lithographic press ('offset press'). This uses drum-mounted printing plates (made of metal, fibre or plastic) to transfer images in ink to a rubber offset roller and then to the paper. Plates are created from colour-separated artwork either by manual and photographic methods ('stripping') or by digital platemaking machinery directly from an image data file ('direct to plate' or DTP). The process of separating the image and creating the plates is called pre-press work. In a four-colour offset press there is one plate/offset roller combination for each of the four CMYK colours to be printed. By pulling a continuous band

(or web) of paper from a drum through the press through each colour's set of rollers in turn, it is possible to print full-colour artwork at an extremely high speed.

Colour offset lithography is a complex process. Lithographers are skilled tradesmen, and the cost of their labour plus the expense of running a large web press places colour litho printing beyond the financial means of the average amateur publisher. My advice is to do your colour printing using cheaper methods. For example,

digital printing technology can now produce colour reproductions at a reasonable price. But if colour DP is beyond your means consider colour xerography, spot colour printing, sheet-fed offset printing, or some other cheaper method.

Before you make a decision it's always a good idea to discuss your printing requirements with the sales rep or press tech at your local print shop. He or she will be happy to advise you on the method best suited to your needs and budget.

A four-colour press run

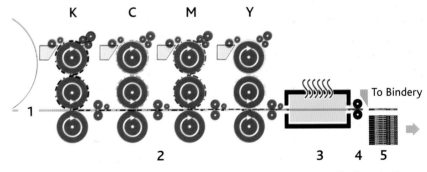

K C M Y

To Bindery

Step 1
Web (paper) is fed into the press from the drum...

Step 2
...through K (black), then C (cyan), then M (magenta) and finally Y (yellow).

Step 3
The printed web is drawn through a drying oven.

Step 4
Chill rollers set the inks permanently into the web and a hydraulic guillotine

automatically cuts the web into sheets ready for collation.

Step 5
The collated sheets are folded and sent to bindery machine.

Binding

A book isn't a book until it's bound. But there's a right and a wrong way to do it. Don't spoil your hard work by opting for the wrong method.

You've written the story. You've drawn the pictures. You've toned, lettered and even printed your manga. But it's just a pile of paper until you put it together into a real book. The process of joining pages together inside a cover is called binding. With the tools and techniques available nowadays, you can slap together a pretty slick volume in no time – but before we discuss the right way to do so, let's take a quick look at the many wrong ways.

The wrong way

When it comes to binding your manga into a book, the only decision that you and your circle really have to make is: do you do it yourselves, or do you pay for someone else to do it. Since we're making manga the B-Chan way, that probably means you'll do it yourselves – cheaper that way, you know. But danger lurks in every office-supply store in the form of bad do-it-yourself binding methods, which are fine for putting together office memos, village-fair cookbooks and primary school book reports, but utterly unsuitable for

holding together a book that someone might actually care to read. The four methods to avoid are:

1. Straight-thru Stapling
2. Plastic Comb Binding
3. Spiral Wire Binding
4. VeloBind® Binding

The right way

No, if you're going to do your own binding, there's really only one choice: saddle stapling.

Staplers

If you plan on doing your own saddle stapling, it's a cinch you're going to need a stapler – and your ordinary one isn't going to cut it, so put it away. Now, here are two that will: the Swingline Model 615 saddle stapler binds on the fold to make booklets of up to 120 pages using #35150 round wire staples. It has an 8in./20cm reach – just right for manga. The Stanley Bostitch Extra Heavy Duty Stapler staples up to 250 sheets at a time using a wide variety of Bostitch SB35 heavy duty staples. Either one is good value – or you could buy both and halve your stapling time.

1. Straight-thru Stapling
To paraphrase Truman Capote, 'that's not binding – it's just stapling'. After only a few flip-thrus this mass turns to a mess of frayed edges and fallen-out pages. For office use only.

2. Plastic Comb Binding
You have to use a special machine to punch the holes and bend the comb through them. Ordinary paper is far too weak for this; the holes will quickly tear with repeated use. Just don't.

3. Spiral Wire Binding
Similar to the plastic comb method; uses a coated wire coil in place of the plastic comb, but the dorky effect is very much the same. Makes for a great school notebook...

4. VeloBind® Binding
Pages are clamped together between thick plastic strips. Plastic spikes from the top strip fit into holes in the bottom strip. A special gizmo trims the spikes off and melts them together. Very business-like and secure; not very manga-like.

Saddle Stapling versus Perfect Binding

Again: the choice is either to bind it yourself or to send it out. If you choose the former, the method you want to use is saddle stapling. We've touched on it opposite; but the important thing is to always staple from the outside to the inside. Just nestle the sheets of the book in the correct order inside one another like a saddle over a horse's back, then place the stack of sheets into your stapler with the cover on top. Punch the staples cleanly through the cover and all the pages along the creaseline; when you're done, you should see the two staples folded into the crease in the gutter of the book's centre spread. By putting the open ends of the staples safely in the middle of your

book you prevent them from snagging on clothing, skin, etc.

Having said all that, the best way to do binding is to send it out. Not only will the professional bookbinders do a better job than you can, they can bind your manga into an actual book – a volume with a stiff, flat, glued spine instead of the mere crease of the saddle-stapled book. This kind of binding is called square binding or perfect binding, and it is perfect for

manga. Not only does it give your book a professional appearance (and a spine upon which to put the book's title!), in many cases it can be done on the same machine that does your digital printing – which saves time and hassle. My advice is to always choose perfect binding if your book's page count permits it – you'll find it goes a long way towards setting your book apart from the pamphlets published by the Other Guys.

Booklet Format
The booklet format produced by saddle-stapling is a durable, inexpensive and convenient way to get your comics out in print.

Book Format
If your manga has a high page count (say 50+ pages), saddle stapling starts to lose its lustre as a method of bindery: not only will a thicker book not fold well along the crease, but it's hard work punching a staple through all that paper — and, as you all know, the B-chan

method is all about avoiding hard work whenever possible. Therefore, if your comic fits the bill, please consider perfect binding — and be sure to talk with your print rep about it before signing on the dotted line. Otherwise you might find yourself with an unexpected binding bill.

Convention Marketing

Once you have printed and bound your books, you need to go out and sell them. The best and most direct way is to head for a manga convention.

Anime and manga conventions ('cons') – gatherings of anime and manga hobbyists usually held in big hotels or convention centres – are the natural market for your manga. People come for no purpose other than to enjoy anime and manga; they are open to self-published material, and (most importantly) they have money and are eager to spend it. Why not get them to spend it on you?

The key to convention marketing is the table. The table is your booth, your store, your lemonade stand in the front yard. There are generally two kinds of tables for sale at cons: the Dealers' Room table, which is in a special room restricted to officially recognized dealers (i.e. people whose business is buying and selling anime/manga-related merchandise) and the Artists' Alley table, which is in an area (often a promenade or entrance hall) open to anyone who cares to buy a table. Artists' Alley is the souk of self-publishers, the bazaar of the bizarre – a marketplace by and for amateurs. It's perfect for what you're trying to do.

To get an Artists' Alley table, go to the website (or paper flyer) of the convention you wish to attend. There, listed among various contact data, you will find a phone number or e-mail address (or both) for Artists' Alley Reservations, or something similar. Once in touch with the responsible party by phone, find out what table sizes they offer, and make a reservation for one. It's also

worthwhile buying some membership badges which will give you and your fellow members access to all areas of the convention. (Many cons will give you a free badge if you buy a table and/or work as a volunteer on the con staff. Check with your convention staff regarding their policy on handing out complimentary badges

Unless you live close to the site of the con, you will need to rent a room at the hotel where the con is being held (or one nearby). You and your fellow group members can use the room as a refuge when you're not on table duty; and of course you can keep your clothes, valuables and supplies there. One room is all you'll need for four to five people; ask for the special convention rate when making a reservation and you'll often get the room at a substantial discounted rate.

Once your table and room are secured, it's time to plan how you're going to use them. The best way to do

this is to create a duty roster detailing who will be working the table at a given time. It's best to work the table in two-person teams, so divide the group up as best you can into A Team, B Team, etc., then schedule these teams for duty in such a way that everybody ends up working a more-or-less equal amount of time. The night before the con, get everyone together, pack all your merchandise and supplies, and go over the schedule together so that everyone knows where they are supposed to be at any given time. It's zero hour!

Con Ops

On the day of the convention, set up your table and arrange the books in such a way that they're attractive and easy to see. You should be ready at least a half-hour prior to the opening of the con. You're now ready to sell!

The Artists' Alley is a bazaar. In a bazaar, merchants spread their wares out along a path frequented by browsers and attempt to atttract them to their merchandise. As soon as the con opens, the Alley will fill with people; your job is to make these passers-by aware of the existence of your book. The best way to accomplish this is simply to be friendly. Don't go for the hard sell – it annoys people; instead, catch their eye as they walk past, smile and offer a sincere 'Good morning'. If they continue on their way, keep smiling – they'll be back. If they do approach, engage them in light conversation while allowing them to examine the display copies, making sure to answer any questions they may have. If they seem interested, feel free to point out the aspects of your book that make it unique, but, again, avoid the hard sell. If they do choose to buy – hooray! Why not offer to throw in a tchotchke item (see above right) at no cost, before you announce the price and take their money.

Important: do not put a customer's money in the cashbox until the sale is complete. After the customer hands you the cash, place this on the table between you in plain sight and give them any change.

Your table should have a fabric cover (a clean, unwrinkled bedsheet is fine), be neatly arranged and free of clutter, and should have the merchandise displayed front and centre. Make sure you have a couple of display copies of the book set apart for browsing. You'll also need a metal cashbox with some cash in small denominations, plus a clipboard with attached pad and pen for your contact list, a notepad, a pocket calculator, various pens and a couple of stacks of tchotchke items — little giveaway gimmicks such as badges or postcards that you can use as bait for browsers. And you'll need chairs, of course!

Ask your customer if they want to be on your contact list of people to be notified of future projects; if they do, have them write their name and e-mail/postal address on the sheet you've provided.

Once you've handed them their purchased items, ask them, 'Will that be all?', and wait for an answer. If they reply that the transaction is complete, offer them a hearty thanks as they walk away. It's now okay to put the money in the cashbox.

The thrill you feel as that lovely, lovely money changes hands for the first time is hard to describe. It's something like a first kiss – a heady mix of ego-boost and wonder, only combined with the power of cold hard cash.

(Your circle may want to set aside a note from your first transaction and have it framed as proof that total strangers will pay to read your material. It'll look great hanging on the wall back at the meeting place!)

Mission SWAG!

Generate interest and awareness in your work by producing promotional items, and participating in panel discussions that are held at conventions.

Remember how I told you that your objective is to attract people to your table? Well, there's only so much you can do while you're standing behind that table. After all, a great many people who go to conventions never venture into the bawdy and untamed environs of the Artists' Alley. You and the gang are going to need to do something to let these people know that Something Cool is going on down there at your table. The way you do this is by making small, cheap and, hopefully, cool promotional items (promos) and deploying them in areas where the people you want to attract hang out. We call such promo items swag.

People love getting anything for free. Swag (pronounced 'shwag') can be anything inexpensive and colourful that tends to catch the eye. I've found that postcards, stickers, decals, temporary tattoos, mini-comics, toys, charm items and the like are all ideal for swag purposes because they are cheap to produce using home

equipment, don't take up much space in your baggage and have some small practical – although momentary – value.

The crucial aspect of successful swag is that it points the way to your table (or website). If the con has assigned numbers to the tables in the Alley, your swag should feature your table number; if not, a general invitation to visit the Alley should suffice. To use swag, simply place it on one of the numerous free tables you'll find here and there in the main traffic areas. These are set aside for the free exchange of promo materials and are usually covered with a thick layer of flyers for fan clubs, other conventions, room parties, bands, games and, of course, other people's swag. To use this valuable promotional resource, just drop off a small stack of swag every few hours and check back occasionally to see how it is moving.

Stickers, badges, mini comics and postcards are all acceptable forms of swag.

Panels

Another good way to promote your circle's work is to participate in panel discussions ('panels'). Panels are listed in the programming schedule section of the con's Programme Book (you did remember to grab a Programme Book, didn't

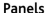

you?) and are generally organized by area of interest, called a track. For example, most cons have a Video Track consisting of panels related to video production; others will have a Costuming Track listing all the panels related to costuming, and so forth. The track you want to look for is the Art/Self-Publishing/Manga/Small-press Track. In a typical panel, you show up to a meeting room (a panel room) where an individual or expert in a given field of interest makes a presentation related to the practical aspects of that field. During the panel, the audience are encouraged by the speaker(s) to ask questions, which usually triggers a discussion involving both the speaker(s) and audience members. It is possible to learn an incredible amount of solid, practical information, so I heartily encourage attendance by all.

The promotional aspects of panels are twofold: first, you can promote

your table or project by the way you ask questions as a member of the panel audience (e.g. 'Hi, Mr Lewis, I'm Veronica Magsaysay of the Saturday Afternoon Manga Circle, and I was wondering…'), and second, by being invited to participate as a speaker. Many cons have panels called 'Dohjinshi Roundtable' or 'Small-Press Publishers Speak Out', which are open to speakers of all levels of experience. By calling the convention's Programming Director well in advance, you might be able to convince them to invite you and/or the rest of the circle to speak on such a panel. In such cases you not only usually get a free badge or some other valuable consideration (after all, you are working for the con in such circumstances, and deserve to be compensated somehow) but you get your circle's name listed in the Programming Schedule and thus gain a measure of instant credibility in the minds of the buying public. At the very least, you can promote your circle from the lofty heights of the panel table. It's just like getting a free commercial!

Networking

There are a lot of conventions, and conventions can be a lot of fun – each one an exciting travel destination as well as a great sales opportunity. Networking is perhaps the biggest benefit you'll get from attending. By meeting and hanging out with people in the hobby and industry, you'll

expand your circle of friends and, yes, improve your position as an artist – because friends help friends.

Discipline

While conventions are fun, they are also hard work. People don't part with their money easily, and the competition is stiff. If you're going to do well as a con marketer, you're going to have to get up earlier, work later, and put out better product than the folks at the next table. That means observing personal discipline – the ability to forego pleasure in order to fulfil one's duty – and direction, the ability to focus on the task at hand. You must also share in the work that has to be done – no sleeping in when the table has to be manned, no coming to the table all rumpled and wrinkled. And it goes without saying that you must maintain the strictest standards of behaviour, decorum, hygiene and age-appropriate behaviour at all times.

The Green Room Door

Somewhere in the long, empty hallways of almost every convention, a door exists – a door that opens on to a world of opportunity for those who will open it. I call it the Green Room Door. (A green room is a room run by a convention as a private sanctuary for invited guests and their families and other VIPs.) For some people, the Green Room Door opens on to a chance to advance their careers as an artist. For others, it might conceal a conversation with a colleague that will spark a whole new way of thinking about art. As you begin your journey into the complex, crazy and always-surprising world of conventioneering, remember to keep your eyes open; your own personal Green Room Door may lie at the end of the next hotel hallway – down at the dark end, by the ice machine.

When you find it, throw it open with all of your strength and dive on through.

The ISBN: Gateway to the Bookworld

Once you have an ISBN for your book, you have access to the endless digital 'shelf space' of the Internet booksellers.

Enter the ISBN. The ISBN (International Standard Book Number) system is a numerical bibliographic indexing system that creates and assigns a unique 10-digit identification number to each published title (or edition of a title) from one specific publisher. The ISBN system was created in 1966 by the British bookseller and stationer W H Smith. If you want your circle's book to be a part of the universe of legitimate publishing, you're going to need to know how ISBNs work and how to get one of them.

Here's what to do. The ISBN indexing standard is defined and administered by the International Organization for Standards (ISO) and forms a section (ISO 2108) of its global system of standards. (Beginning on 1 January 2007, ISO will be changing the global ISBN Standard to a 13-digit ISBN, thus conforming the ISBN system with the UPC barcode system.)

How to get ISBNs

The ISO defines what an ISBN is – but who assigns each ISBN to each book? In the USA, a privately owned bibliographic data corporation, R. R. Bowker LLC, a division of the Cambridge Information Group, Inc. of Bethesda, Maryland – the same company famous for *Publishers Weekly*® and *Books In Print*® – is the agency officially designated by the ISBN System as being responsible for the assignment of the ISBN Publisher Prefix to US publishers (including foreign companies who are publishing

their titles within the US). Bowker UK Ltd serves customers in Europe, Africa, the Middle East and Asia, and Thorpe-Bowker is the ISBN Agency in Australia and New Zealand; other countries have their own agencies, but all tie in to the same global ISBN system.

To get an ISBN, you simply purchase it from the ISBN agency in your country. The contact data for various ISBN agencies can be found at your local library or on the Internet. In the case of US ISBNs, the process can be completed online – you just go to the website, order however many you want using their interactive forms, and pay. Bowker then assigns the ISBNs, registers them as belonging to you, and sends you a computer printout by mail for your records.

ISBNs in Bookland

Once your book has its own unique ISBN, you're going to want to put it in the book, of course. Place the ISBN number in the indicia – the block of text containing the book's copyright notice, year of publication, publisher's address and all the other useful

bibliographic data.

You're also going to want to put it on the back cover of your book – in the form of a Universal Product Code (UPC) block, or barcode. There are several vendors on the Internet that will create these barcodes for you, or you can do it yourself on your computer with special software. With the addition of a separate five-digit barcode containing the book's currency and recommended retail price data, you make the book's ISBN data machine-scannable – and that transports it into bookland, the magical realm where commercial books live.

Once your book is in bookland, your little home-made volume gains instant legitimacy: it becomes a title – a publication suitable for listing in the wholesale or retail book dealer's computerized inventory. With your ISBN safely registered, the world of online bookselling opens up to you – Amazon.com, Barnes&Noble.com, and all the others – giving you access to the most powerful bookselling tool. Bookland is a great place to be!

Webmarketing

Webmarketing is the practice of marketing your products directly to potential customers via the Internet, and it is a powerful method indeed.

The other advantage of the Internet is webmarketing, by creating and operating a website dedicated to your artistic output. Whole books have been written about how to do this (see Further Reading), so you don't need me to cover that ground all over again here, but suffice it to say that the two most important properties a website can have are great content and transparency.

Content is the actual stuff folks visit your site to experience: fresh, high-quality and regularly updated manga, cartoons, illustrations, stories, articles, videos, music files, etc.

Transparency is the quality of making the content of your site easy to find and access by the user. A well-designed website doesn't get between the visitor and the content they came to see; instead, it operates as a silent and almost invisible interface (method of communication) between them. A website that provides a clean, classy and easy-to-use interface between visitor and content is said to be transparent.

My advice is to set up a website for your circle as soon as possible. Your site need not be anything complicated or fancy, but it does need to be attractive, content-rich and transparent; if you can't create such a site, do yourselves a favour and pay someone who knows what they're doing to create it for you. You'll be glad you did.

A sample website for a small manga circle:

A. The index page (or home page) of the site, featuring the name of the circle, an index to the site's content and online biographies of the creators. In this example a visitor can see the biography of a given member if they hold their cursor over the face icons.

B. Rolling the cursor over the Latest Manga link brings up a feature page containing a manga feature by one of the creators, in a format that allows the visitor to read the manga by clicking the coloured arrows to advance the pages.

C. A quick roll over The Funny Pages link brings the visitor to a webcomics page, where circle members can post online comics creations

D. Rolling over The Circle Journal link calls up a constantly updated news page, with information on the circle's latest doings, con appearances, new releases, etc.

And finally, rolling over the Downloads link brings the reader to the library page — a place where the visitor can download manga, video files, music files, or whatever else they want to their own computers.

Index

Index

Acknowledgements

First: affection and thanks to those of you, both students and friends, who have sat through my lectures at conventions over the years. I hope you like the book!

Thanks to: Juku (Edward Hill, Dan Baker, Shaindle Minuk, and David R. Merrill); Michael P. Willeford, Kenneth W. Alewine, Lee D. Norris, Joseph D. Glennon, and Darryl Draper; John Cole and Scott Fleming; Rikki and Tavisha Wolfgarth-Simons; Robert and Emily De Jesus; Ryan Gavigan; Heidi Brown; Chris Wisner and Ryan Fisher; Jaemin Deal; Brett Weaver and Elizabeth Kirkindall Weaver; Megan J. Taylor RN; Brian Johnson and Heika Muller; Justin "Shelf Dude" Rhodes; James Gordon, Corinne "Binky" Gordon RN, and family; Christopher Head and family; everyone at Paperbacks Plus Lakewood and all my Lakewood Heights Homeboys; Edith De Golyer; Kevin and Emily Garten; Cliff Spears; Glen Oliver; Steve Harrison; John Ott and family; Tim and Genni Eldred; Gregg Kuniak; Edd Vick; Trish LeDoux, for giving me my first shot at manga writing; Helen McCarthy and Steve Kyte, James Swallow, and Jonathan Clements for invaluable guidance and advice; Widya Santoso; Amos Wong; Donovan Floyd and Reed Julian; Clay Salmon, Derek Wakefield, and Kenneth Riggs; Jan S. Frazier, Douglas Smith, Rana Raeuchle, and Greg "Greggo" Wicker; Monica and Miguel Rial and family; Greg Ayres and family; Neil Nadelman; Keith Colwin and the folks at Keith's Comics (Dallas), for all the years of encouragement and support; Michael and Wendy Battle; Stephanie Folse; Kevin and Emily Garten; Lauren and Leslie Forrester; C.B. Smith and Elizabeth Christian; Clarine "Aubrey" Harp, Christopher Bevins, and the troops over at Funimation; Josh Roberts, Michael Tatum, Eli and Andy Schlabach and the South Davis Viper Pilots Club; Christopher and Melissa Brown; Timothy Czarnecki; William Jordan; Sara Yovich; Meri and Dean Davis and family and all the A-Kon crew; Steven and Kevin Bennett; Rich "Radman" Anderson; David Van Cleve and all my homies at Psychommu Gaijin; Jessica Calvello; Matt Greenfield, Tiffany Grant Greenfield, and everyone at ADV Films; the Reverend Allan Hawkins and family; the Catholic Parish of Saint Mary the Virgin; and all our friends and loved ones throughout the world. (This list edited for length.)

The author wishes to especially thank Mr. Frederik L. Schodt, who started the whole manga book thing 'way back in '82 and without whose kind assistance this volume would never have been conceived, much less published; and Mr. Carl G. Horn, for his invaluable advice and support throughout this project. Also thanks to Miranda Sessions, my editor at Collins and Brown.

Special thanks to: my mom and dad, Frances and John Lewis; to my brother Tim and sister Stacey and their families; to my late grandmother, Eula L. McGee; to A.E. and Rachel Fischer, Donald "Beerfoot" Fischer, and the Reverend Charles Fischer and family; to John Case Jr., Donnie Case, and their folks and families; to the rest of our beloved families in Texas, Oklahoma and elsewhere; and to Laura Block, Pharm. D., and Danny Block, with deep affection.

Extra special thanks and love to my aunt Carol McGee, without whose love and influence I wouldn't be doing any of this, to her husband Clyde McGee, and to my dear cousins Vincent, Thomas, and Christopher, and their families;

And of course my greatest thanks and love to my dear wife, Mundee M. Lewis, the real artist in our family.